Art and Production

Art and Production

Boris Arvatov

Edited by John Roberts and Alexei Penzin
Translated by Shushan Avagyan

PlutoPress
www.plutobooks.com

First published in Russian 1926

This edition first published 2017 by Pluto Press
345 Archway Road, London N6 5AA

www.plutobooks.com

Copyright English translation © Shushan Avagyan 2017;
Introduction © John Roberts 2017; Afterword © Alexei Penzin 2017

Financially assisted by the V-A-C Foundation, Moscow

V————— a – c

British Library Cataloguing in Publication Data
A catalogue record for this book is available from the British Library

ISBN 978 0 7453 9945 4 Hardback
ISBN 978 0 7453 3736 4 Paperback
ISBN 978 1 7868 0125 8 PDF eBook
ISBN 978 1 7868 0185 2 Kindle eBook
ISBN 978 1 7868 0184 5 EPUB eBook

Typeset by Stanford DTP Services, Northampton, England

Simultaneously printed in the United Kingdom and United States of America

Contents

Acknowledgements

Boris Arvatov (1896–1940) has long needed an English-speaking audience for his work. Hopefully, this present book will be the basis for other translations of his writing into English. We would to thank the University of Wolverhampton and the V-A-C Foundation, Moscow for financial assistance with the translation, and the V-A-C for its financial commitment to a new, commemorative issue of Art and Production in Russian. This gives an opportunity for Russian readers to read a book long out of print. And finally, we would like to thank Shushan Avagyan for her excellent translation, and Anne Beech at Pluto for supporting this project.

John Roberts and Alexei Penzin,
15 February 2017

Introduction
Art and 'Life-building': The Legacy of Boris Arvatov

John Roberts

Boris Arvatov's *Iskusstvo i proizvodstvo* (*Art and Production*) was first published in Moscow in 1926, and was published in an amended form in German (*Kunst und Produktion*) by Carl Hanser Verlag, Munich in 1972, and then in Spanish and Italian the following year. As with many other key texts from the Soviet avant-garde from the 1920s and 1930s, its reception in the Anglophone world has been fragmented and beset by hearsay. So on the hundredth anniversary of the October Revolution, this first English translation is an excellent opportunity for English readers to acquaint themselves directly with a canonic, revolutionary and avant-garde text. I say directly, for although the work still awaits a wider readership, Arvatov's thinking has had a significant impact on the Anglo-American, new Soviet avant-garde studies and art history over the last 20 years. Christina Kiaer's *Imagine No Possessions: The Socialist Objects of Soviet Constructivism* (2005) and Maria Gough's *The Author as Producer: Russian Constructivism in Revolution* (2005), both draw on Arvatov and his theory of art-as-production, as a way of redrawing the conventional historical map of the Soviet avant-garde –

that Arvatov's Productivism[1] was a failure, certainly compared to the successes of Constructivism – and of testing some of the unexamined assumptions of contemporary art theory. Thus, there has been an interesting convergence between the Arvatov theorized in these two books, and the recent 'social turn' in contemporary art and theory globally, with its emphasis predominantly on 'social construction' and the necessary temporality of artistic production, as opposed to the gallery-based display of art objects and image production.

This does not mean that we can impose Arvatov's thinking onto this 'social turn'. The revolutionary conditions under which Arvatov develops his notions of art-as-production and 'life-construction' or 'life-building' are, for all obvious reasons, very different from today. Yet, Arvatov's thinking, driven as it is by the political, technical and cultural demands of the early years of the Russian Revolution, addresses some of the substantive problems and issues that define the post-traditional status of art in the twentieth century and today. What might art do once it steps outside of the studio and gallery? What kind of skills and resources might artists rely on once they abandon painting or freestanding sculpture, or even photography? In what sense is the artist a 'collective

1. There is some terminological ambiguity over 'Productivism'. Arvatov himself doesn't use the term, preferring mostly 'productionist art' ('proizvodstvennoe iskusstvo'); also contemporary Russian scholars, such as Igor Chubarov, tend also to use productionist art or 'Productionism' ('produkzionism') (*Kollektivnaya thuvstvennost's: teorii i praktiki levogo avangarda*, Izdatel'stvo Vyshei Shkoly Ekonomiki, Moskva, 2014). However, in Anglo-American, German and French art history (Christina Lodder, Maria Zalambani, Brandon Taylor, Christina Kiaer and Maria Gough), it is 'productivism' that is preferred, given the tendency of Western art histories to taxonomize through 'isms'. In order to maintain a semblance of continuity, I use 'Productivism' here.

worker', in the same way that the labour-power of workers is organized collectively? How might artists contribute to a collective product or process? How might artistic creativity, then, be directed to the transformation of social appearances and the built environment? As such, in what ways is the artist now – after the crisis of art's traditional artisanal function – a *specialist in non-specialism*, so to speak, a producer of things and meanings across disciplinary boundaries and practices?

All these questions preoccupied Arvatov and his generation of Constructivists and Productivists, just as all these questions dominate the theory and practice of the new participatory and community-based, post-object art today. Yet, if there are clear overlaps here, there is one thing that concerns Arvatov more than anything else. If art – in the second decade of the twentieth century – is now post-artisanal having left the traditional arts behind, and the artist's skills, therefore, are part of an extended social division of labour, is it possible for art to actually enter the relations of production itself? Can art in fact contribute to, and help direct, economic production? Arvatov believed it could, and should. That is, for Arvatov, the revolutionary and technical changes of the Bolshevik Revolution not only demanded a cultural reorientation of art's priorities – consciousness raising; new forms of cognition through art and film – but a material-functional reordering of art's use-values. If art was to truly transform its bourgeois identity and escape its old hierarchies, if it was truly to accept its post-artisanal and post-aesthetic condition, then it should make itself available to the technical demands of modern industrial labour. This would involve, necessarily, not only a radical transformation of the artist and the category of art itself, and the materials artists work on; but also, most importantly, the very *site* of artistic production. In short: the

artist should enter the factory. For if artists were technicians and labourers above all, then where else should their skills be better used and developed, but amongst other labourers and technicians?

As such for Arvatov this involved a radical rethinking of the artist's creativity, even within the functionalist ambitions of Constructivist circles, which were still too attached for his liking to a model of the individual producer and to art as revolutionary representation and social decoration. Opposed initially to Constructivism's research-based artistic functionalism, he encouraged artists to think of themselves as technicians who had finally left the self-image of individual creativity behind, even when this individuality was attached to collective projects or to the educative requirements of the new state. Thus, rather than designing revolutionary objects, symbols or propaganda-tokens – or even revolutionary-functional objects in the spirit of Alexander Rodchenko's famous information kiosks (1919) – artists should subordinate their technical skills to the greater collective discipline of the labour process and the workshop. For it is in the factory and the workshop where the erosion of the distinction between workers (as culturally excluded) and artists (culturally privileged), individual ideas and collective creativity will be tested and challenged in practice, and the real work of a new egalitarian culture created. Artists, then, should enter the factory as part of the collective transformation of the relations of production called forth by the revolution, and by the demand to transform production for profit into production for need. Accordingly, artists should not simply join the technical staff or the production line in order to do the bidding of technicians and managers, but work in dialogue with managers, technicians and labourers on transforming the content and form of industrial labour

and the life of the factory. And to do this convincingly, artists should know as much about the given labour process as those technicians and labourers who labour in the factory themselves.

Hence, under these conditions artists require a different 'skill set' than anything hitherto expected or demanded of artists in bourgeois culture: they should be able to think of what they do creatively as part of teamwork, and – in situations where 'expressive values' are not required – should think of making as a contribution to the solution of the formal and technical problems of production. To do this, Arvatov suggested that it would be better for artists to bypass art schools and art academies altogether, and go and study engineering and the sciences. This would then allow artists or artist-technicians to expand the use-values of art and the meaning of creativity to the productive and scientific realm generally. By increasing the technical and scientific knowledge of artists, artists would be in a position to have a determinate say over the big decisions of production: what is to be produced, with what resources and with what scientific inputs and to what ends. In this sense the functional and practical field of operation of the artist becomes the modern intellectual and social division of labour itself. 'Socio-technical purposiveness is the only governing law, the only criterion of artistic, i.e., form-inventing activity'. Thus, if the confidence of this vision is, at one level, defined by an avant-garde revaluation of all values common at the time, it is also, on another level, an immediate response to the chronic crisis of Soviet industry after the Civil War; factories were running at extremely low capacity, given the shortage of raw materials and workers. Therefore, there was a cognitive dissonance between what factories were realistically able to produce and Bolshevik images of a new industrial culture.

Productivism's concern with the qualitative and technical problems of labour was, consequently, a response to this gap, and to the general underdevelopment of economic production in conditions of general need. Improving the technical conditions of the labour process and productivity, for Arvatov, was the first step in the revolutionary transformation of the relations of production.

This radical re-visioning of art and the artist under the auspices of this new productive role is the theme of *Art and Production*. Written during the cultural maelstrom of the early years of the revolution, when artists and intellectuals were beginning to rethink all aspects of visual culture and the identity of the artist, it sees the revolution as a harbinger of an epochal change in notions of 'making', 'doing' and 'creativity'. Arvatov's principal theoretical concern, therefore, is to delink the received assumptions about what artists do from the practical demands and emancipatory horizons of the 'new age of labour'. As such his primary concern is to re-define the wholly limited understanding of creativity historically in bourgeois culture and the rise of the autonomous-aesthetic artwork produced (by an individual practitioner) for exchange on the market. In this he follows Marx and Engels of *The German Ideology* (1846) and the Romantic anti-capitalism of William Morris and John Ruskin, in insisting that this shift was fundamentally detrimental to the social use-values of art. Art became subordinate to the discrete aesthetic interests of practitioners, patrons, collectors, and art's small bourgeois audience, separate from art's communal and shared function.

Unlike Marx and the Romantic anti-capitalists (largely writing before the full industrialization of culture), Arvatov is not interested in the fate of the individual artwork under these conditions: that is, certain artworks lack of a general audience,

or the increasing separation of artistic skills as the measure
of human creativity and autonomy and the routinized skills
of the industrialized worker. This is because such issues are
secondary to the fundamental question of art's technical
and social organization under Soviet post-revolutionary
conditions. Art now is not about the production of *things* as
exemplary things, 'for all', or even non-exemplary things, but
the production of new material relations in which things
will be divorced from the weight of their fetishization. This
is what appears remarkably stark about Arvatov's historical
account of the bourgeois period in *Art and Production*: all
artworks, irrespective of their achievement, incomparable
aesthetic value, or critical significance, ultimately represent
the failure of humanity to organize creativity on an equal
and non-dominative basis. Arvatov's idea, accordingly, that
art is 'unorganized' under bourgeois culture, is not nihilism,
crude scientistic functionalism, or Jacobin disgust at privilege,
but represents a sober epistemological assessment about
what is truly revolutionary about the Russian Revolution for
humanity.

For Arvatov, as for his comrades in Left Front of the Arts
(LEF), the Russian Revolution is, for the first time in history,
a moment when the majority of people possess the possibility
of transforming culture in their own interests as a process of
collective free creation. Removed from the domain of narrowly
defined aesthetic tradition, 'art' in its non-professional capacity
as shared technique, becomes the everyday domain of skilled
and unskilled, artist and non-artist, professionally trained and
amateur alike. In this way the relationship between creativity,
techniques and praxis, undergoes a fundamental realignment.
Divorced from the production of discrete aesthetic objects
largely for private consumption, artistic judgement and

technique are 'externalized' in modern technical processes, enabling these processes to contribute to the overall socialization of culture across practices, disciplines and classes and therefore contributing directly to the 'processes of life-building', (*processy zhiznestroitel'stva*). Arvatov calls this interconnection between the socialization of culture and everyday practice, 'general social technique' (*obsche-sozial'naya tekhnika*), as a way of highlighting the transformative opportunities afforded art and culture by the new technical and technological advances of the new industrial epoch. As such, the major proletarian task of the Productivist revolution in art is the 'eradication' of the distinction between artistic technique and general social technique. For, without the breakdown of this distinction, there can be no practicable entry of art into 'life-building'.

The link connection between 'life-building' and 'general social technique' is Arvatov's version of the familiar avant-garde notion of the subsumption of art into life. Art dissolves itself into life-process, as the precursor to the general dissolution of the distinction between intellectual labour and manual labour, of creative labour and routinized or instrumental labour, of artists and workers. But for Arvatov, this isn't simply, a matter of extending the forms and judgements of art *into* everyday life but of challenging what is meant by 'art' and 'everyday life', 'art' and 'production' as such. Hence: the central importance of 'organization' to his Productivist vision. Art's contribution to life-building lies, not in the aesthetic re-enchantment of the everyday, of the application of an external aesthetic uplift to all things – 'aesthetic gourmandism' he calls it – but in the artistic re-functioning of the practicable domain of objects and their relations, beginning with production itself. In the hands of the artist-technician and proletarian-as-artist:

In its hands the machine, the printing press in polygraphy and textile printing, electricity, radio, motor transportation, lighting technology, etc., can become versatile but incomparably more powerful instruments of artistic labour. Thus, the revolutionary task of proletarian art is the mastery of all kinds of advanced technique with its instruments, with its division of labour, with its tendency to collectivize, and with its methods of planning. A unique 'electrification' of art, engineerism in artistic labour – this is the formal purpose of contemporary proletarian practice.

Thus, the challenge to the distinction between creative labour and productive labour, artistic technique and general social technique, has to begin at the point, historically in the modern period, where this distinction is overwhelmingly grounded – production in the factory – if the revolution is to be more than a revolution in ideas, appearances or cultural sensibility. Arvatov's decision to focus on the factory is the result, therefore, of a deliberate political and philosophical decision: to take the revolution to the heart of labour, as a way of drawing out the truly emancipatory possibilities of the revolution.

That this creates all kinds of practical problems is not at all surprising. The Party was suspicious of outside intervention in factories, particularly by artists; the workers were suspicious of those – non-workers – keen to work along side them; factory managers – Red Managers – were suspicious of meddlers, particularly those who had an agenda, and were keen to talk about workers' organization inside the factory and alienation and 'artists-as-workers' and 'workers-as-artists'. Even in the early years of the revolution – in the period of ideological flux and general leftism – the Productivists found it particularly

hard to get inside factories or to get their ideas adopted administratively, no more so than against the backdrop of low capacity, intense speed-ups, and the chronic shortage of materials. However, there was one key exception to this rule: Karl Ioganson's tenure at the Prokatchik metal factory in Moscow, from 1923–4. A member of INKhUK (Institute of Artistic Culture) in Moscow from 1920–24, and the producer of freestanding geometric ('spatial') constructivist sculptures, Ioganson was employed as a metal cutter in the factory. But, presumably on the basis of his wide technical skills and knowledge, it appears as if he was also allowed by management to contribute to the rearrangement of workshop practices, through the invention and application of a new kind of device for finishing non-ferrous metals. As Gough says in her extensive and illuminating analysis of Ioganson's tenure:

> In place of the 'handicraft method' of application, involving the hand-dipping of each article in a finishing coating, or perhaps its application by brush, Ioganson proposes a new method, which presumably involves either the mechanization of the dipping process by the construction device attached to an automatic feed or the introduction of spray-gun coating.[2]

Ioganson was very pleased with the success of this, and wrote a report to this effect for INKhUK – his changes certainly alleviated unnecessary injuries and poisoning in the metal-dipping sector. But the success of Ioganson's intervention is less to do with his great powers of persuasion

2. Maria Gough, *The Artist as Producer: Russian Constructivism in Revolution*, University of California Press, Berkeley and Los Angeles, 2005, p. 168.

as a Productivist-inventor and the virtues of Productivist thinking, than the Party's drive for rationalization in the factories under the NEP (New Economic Policy). Ioganson's technical improvement of the dipping process allowed the factory to speed up the production line in the interests of greater efficiency, and was therefore encouraged, without undue worries about avant-garde meddling. As Ioganson says in his report to INKhUK: 'the raising of the productivity of labor by 150%'.[3] This is clearly a source of pride for Ioganson, but perhaps less so for Arvatov, particularly when in 1925, Ioganson accepts a Party job on the shop floor, encouraging workers to accept the Party's new wage cuts policy and higher work norms. Like Ioganson, Arvatov's understanding of Productivism was as a scientific-technical-theoretic intervention into the labour process; as a result, he was no naïf, when it came to the instrumental realities of this kind of intervention, particularly under the severe conditions of economic underdevelopment after the Civil War.

However, Ioganson's inventor version of Productivism was not what defined the organizational character of art in the post-revolutionary epoch for Aravtov. Far from treating Productivism as an adjunct of NEP managerialism or a process of labour-process rationalization, he saw 'organization' in production as part of a wide process, in which art's non-aesthetic integration into non-artistic domains, is in turn integrated into the 'everyday' organization of aesthetic materials and processes. 'The proletarian artist must aspire to creatively organize any kind of material, be it noise in music, street words in poetry, iron or aluminum in art, or circus stunts in theater ... Only such technical tendencies can turn art into the creation of real life.' Therefore, we should

3. Gough, *The Artist as Producer*, p. 168.

be wary of assuming that *Art and Production*'s only concern is with the entry of the artist into the factory; and, therefore, that Arvatov's concept of organization is no more than an expression of NEP rationalization.

Rather, *Art and Production* is fundamentally divided on the question of organization; and, as such, all the better for this. That is, although published in 1926 it already signals a certain distance from Productivism as an economistic version of the avant-garde. Arvatov has clearly incorporated what he has learned from Ioganson's tenure at Prokatchik in 1923–4 and the failure of other Productivist artists on the shop floor (as well the failure generally of artists to enter the factory), into his assessment of art's place in the factory, even if he is perfectly aware that Ioganson's re-fetishization of the object (machine technology) is the result of insurmountable pressures that any artist in similar circumstances would have had little control over.

This is crucial then to how we read *Art and Production* as an avant-garde and revolutionary text, and its significance in the light of art's contemporary 'social turn'. For if *Art and Production* is a book that is absolutely clear about the transformative significance of the incorporation of art technique into general social technique – as the core principle of a new epoch in art – it nevertheless, recognizes that, there are overwhelming problems in achieving this at the point of production. Under the external rationalization of the production process art technique is invariably captured for this process of economic rationalization, irrespective of the artist's technical 'creative inputs' or flexibility. Indeed these creative inputs and flexibility become incorporated-as-standard into the production process, reducing art technique to no more than the technical finessing of the production process.

In the concluding section, then, Arvatov holds back from a fully economistic account of 'organization', in order to retain a critical-research value in art that allows it to operate across all public and disciplinary domains. In this sense it subtly repositions Productivism, within the broader orbit of Constructivism: 'absolute organization is practically unattainable.' Yet, this is not defeatist text, a stepping down from Productivism in response to the impending demise of the avant-garde and the revolutionary critique of the relations of production. There is no sense for Arvatov that the revolutionary sequence from 1917 is coming to end; on the contrary, *Art and Production* is the work of someone, adapting his position heuristically to changing circumstances, in order to reground its revolutionary principles. This is why *Art and Production's* value and importance remain so vivid 90 years after its publication. Even if Arvatov aligns the rationality of art too uniformly with that of the instrumentalities of production,[4] nonetheless, it is precisely his polemical defence of 'organization' in art as a break with bourgeois culture – as a way of 'thinking' art beyond the constraints of aesthetic recompense, beautification or mere depiction – that secure the vitality of the text today, with its question-provoking and limit-defining character, and therefore its philosophical and artistic merits.

4. For an extended discussion of this issue (the fact that Arvatov, initially, at least, was oblivious to the downward pressures of the value-form on art and culture operating during the NEP), see John Roberts 'Productivism and Its Contradictions', *Third Text*, No 100, Vol 23, Issue 5, September 2009, pp. 527–36. See also, Maria Zalambani, 'Boris Arvatov, Théoricien du Productivisme', *Cahiers du Monde russe,* 40/3 Juillet-septembre 1999, pp. 415–46, and Igor Chubarov, 'Productionism: Art of the Revolution or Design for the Proletariat?', *Chto Delat*, 'What is the Use of Art?', Issue No 25, March 2009, unpaginated.

Art and Production throws down a gauntlet to what we really mean by art's social function – what Arvatov calls the 'socializing of aesthetics'. Is art a system of professionalized reflection on representation and forms of 'expression', or is it a realm of multiple and socialized technique, open to all? Is it a form of aesthetic distantiation from appearances, or is it a form of praxis engaged in the *construction* of appearances, an immanent process of articulation and struggle? Is it Idea or is it Idea as Life?

1

Capitalism and the Artistic Industry

The Form of the Artistic Industry

There is no more urgent issue, no more fundamental question in the theory of art than the issue of so-called aesthetic culture.

Art and life – how should these apparently heterogeneous phenomena be connected to each other?

The question stood as a stumbling block in front of bourgeois science and bourgeois practice, unsolved and unsolvable in the conditions of capitalist society.

Indeed, art requires free, independent labour as a necessary condition, whereas the capitalist system either excludes such a possibility, or subtracts free creation from the processes of 'life-building'.[1]

The age of machine capitalism is characterized, first of all, by the accumulation of instruments and means of production in the hands of private ownership, second, by mechanized mass production, and third, by the anarchic spontaneity of economic development. Under such conditions, neither the proletarians, the only true but unfree builders of life, nor the private owners, the non-working element of society,

1. 'Life-building' (*zhiznestroitel'stvo*) is the term Arvatov uses to designate those processes of social construction that have a direct impact on the de-fetishization and de-alienation of capitalist relations and forms which create emancipated forms of communist life (eds).

can become the creators of artistic culture. The worker is subordinated to the machine, while the factory owner is subordinated to the iron law of competition. There is no place for free creation in private ownership production, and thus the main current of social development is separated from the artist by a Chinese wall. Art falls into the hands of specialists from the intelligentsia, who do not produce material values and who are deprived of any kind of possibility (even with good will) of participating in mass labour processes (as an example, we may recall the attempts of the French painter Díaz who made a vase based on his own design in the Sèvres porcelain factory; he was immediately dismissed).

Craft is what is left in the hands of the artist. But if in the guild society of the distant Middle Ages the artist and the practitioner were united into a single whole through the shared instruments of labour (craft), in capitalist society the artist must either perish in a futile struggle or go into the back alleys of life to create outside of it.

Moreover, the artist worked for the consumer in the guild society, whereas in capitalist society his works turn into market goods – the creator is separated from the masses by an impassable line, becoming a refined individualist. Losing his connection with the collective, he learns to see his creative work as something valuable in itself, self-contained, and he accordingly changes the devices and forms of work. The painter no longer paints on walls – he now takes a piece of canvas and frames it; the sculptor does not install his work in relation to the spaces of a building – his sculpture must be subordinated to itself in all senses, it must affect the viewer independently, separate from the rest of the world.

This change obviously did not happen all at once. In the urban society of the late medieval period, artistic creation was

still part of everyday life [*byt*] in every aspect:[2] from dresses, to towels, carpets, furniture and books.

This may have happened for the following reasons. The artist, i.e., the free, conscious creator, found in craft the kind of technique that allowed for his creation: 'Every craftsman functions as the organizer as well as the head of production'[3] – and, indeed, this is necessary for art. It is foolish, of course, to conclude from this that craft is a generator of art, that it always presupposes artistic creation, or, the opposite, that artistic production is conceivable only on the grounds of craft technique, as the consciousness of the bourgeois individualist claims, cursing the machine. The guild craftsman, in his very essence, is conservative: 'The Renaissance epoch possessed such marvellous artistic crafts not because the craftsmen were artists, but, on the contrary, because the artists were craftsmen.'[4]

The artists never thought of removing themselves from life if they could put their talent into the general repository of 'human praxis': 'art for art's sake' was utter nonsense for them or a madman's delirium.

Art and Craft

There is an opinion, according to which art and craft always accompany one another. As proof, those who think this way

2. 'Byt' is crucial to Arvatov's text. In Russian, it has many meanings, two of which are 'everyday life' or 'form of life' and the materiality of things. Etymologically, the latter is close to the word 'bytie', which means 'being' (eds).

3. Werner Sombart, *Der moderne Kapitalismus, Dunkear & Humblot, Leipzig, Modern Capitalism*, 1902.

4. *Ibid.*: 'Craft as a whole (which is the same as the mass of craftsmen) never belonged to the high level of artistic development.'

reference the contemporary 'folk', i.e., peasant, art of artisans and the art of the urban craft epoch of medieval Europe (twelfth to fourteenth centuries).

First, let me address the second example.

If we look closely at the organization and work of the medieval guilds, we shall see that art never entered the realm of their tasks and was even expelled in a most decisive way from production. The work of the guilds was strictly regulated. The making of every object was regulated by strict standards passed down from generation to generation; the objects were made according to specific patterns and moulds, and no original creation was permitted. The craftsmen themselves, as a mass, were distinguished from the rest by their deep conservatism and rigidity, which at the time served as an economically beneficial mode of protection against mercantile capitalism. They killed talented inventors, destroyed technical innovations, and regarded their fellow artists as competitors, despite the fact that most of the artists were members of their guilds.

The perception of the craft epoch as an age of artistic production is a crude illusion, explained typically by the petty bourgeois idealization of the Middle Ages, cultivated among members of the intelligentsia, who worked individually and for whom obviously this epoch of individual (craft) labour seemed Edenic.

Meanwhile, artists, then as now, were solitaries, who had joined their own special artistic groups that worked for a very narrow circle of patrons, city magistrates, the church, large public organizations (such as the guilds), and the elite layer of craft and merchant bourgeoisie.

How, then, can we explain the penetration of art into industry?

By the fact that society had not yet delimited the different forms of labour: any type of labour in this epoch, including the labour of the scientist, the labour of the producer of material values, and the labour of the artist, was individual, as this was the technique of the Middle Ages. Hence, the penetration of one specialization into the other was possible, and the artist could create objects for material everyday life without changing either the social skills of his work or the technical devices.

While the guilds worked mainly and directly for the consumer, the artist made use of all the areas of production. However when social production was subordinated to the market and became more depersonalized, the artist began to handle only the types of labour that were not yet subjected to commerce, namely, crafts that produced objects of luxury. Artists were becoming jewellers, master goldsmiths and so on (fifteenth century), turning into total solitaries, 'masters', 'specialists'.

The capitalist collectivization of production emerged on the basis of the division of labour, competition and the growth of private capital, which made the production process irrevocably spontaneous and therefore intolerant of free, conscious creation. This kind of collectivization touched only material production; the other areas of production remained within the boundaries of individual labour. The artist was stuck in the old technical methods.

Now there was an impassable line of radical differences of methods and forms of technique between him and mass production. The artist remained a craftsman; he was technically backward, even though the process of 'social building' – leaping over workshop manufacture – based itself on the machine.

These changes formed the ideology of the artist: he began to see craft as his 'special' area; it seemed to him that art could not be other than what it was, and he hated the machine with all the might of his craftsman's soul. He did not understand that the problem was not in the technical form of the machine, but in the capitalist use of machines. He thought that the machine form was killing various social possibilities (for creation), when, on the contrary, it was the social, and more specifically, bourgeois form that was killing the creative possibilities embedded in machines. He called for a return to the past, and, like William Morris in England, initiating the organization of the artistic industry, opened craft shops (which, of course, could not compete with machine production and which worked for a small circle of connoisseurs, philanthropists and Maecenases) disconnected from 'social building' and therefore cultivating similar lifeless, archaic forms that imitated, for the lack of their own secure footing, the idealistically deified forms of the Middle Ages. These were reactionary attempts to prevent historical development, to place the backward, dead way of life on the throne of modernity. Such attempts were, of course, swept away by life and they were swept away rather quickly.

The new culture, the culture of the industrial city, could not satisfy the reactionary technique of the artist-individualist, and it is only natural that he escaped to the village, where the techniques that had died in the cities – peasant crafts, artisanal trade – were still somehow alive.

I should emphasize here as clearly as possible that there is no such thing as 'folk' creation, and there never was. It is time that we discard this Socialist Revolutionary[5] utopia in

5. Here Arvatov is referring to the Party of Socialist Revolutionaries, who shared power with liberals and democrats in the Russian Constituent Assembly. After October 1917 they split into pro-Bolshevik and anti-Bolshevik factions (eds).

art and understand that what is called 'folk art' is nothing other than the art of the patriarchal, technically backward, private-property type, petty bourgeois village.

What is more, peasant artistic-artisanal creation does not even exist anymore: it is a phantom, a ghost; a product of the urban aberration of vision. What we have now from art in the artisanal industry are the decaying relics of a past magnificence, the last convulsions of a backward technique, characteristic only of such an economically backward country as Russia.

The artistic forms created in the contemporary village seem to be 'new' only because we never knew or saw them before. In reality, they are the last helpless repetitions of traditional, patriarchal clichés.

The peasant was an artist in the distant past, during the age of feudalism and a self-sufficient household economy. Since then, the introduction of a monetary economy, the rule of the merchant and serfdom instituted by the landowner, killed the technical and therefore artistic progress among the peasantry, and its most gifted representatives either perished within the suffocating frames of aesthetic scholasticism (there are innumerable examples of this in the recent history of iconography, engraving, etc.), or they escaped into the city in rare, serendipitous circumstances (like the village born artist Taras Shevchenko), into the ranks of the intelligentsia and semi-intelligentsia (*raznochintsy* and so on), understanding what the bourgeois *narodnik* can never understand – the inevitability and necessity of standing on the fundament of a high culture and not conserving a sentimentally popular 'primitivism, sweet, only for those with over-refined hearts'.

But they also advance other arguments in defence of artisanal art in Soviet Russia: they argue, first, that it is easier

to carry out the fusion of art and labour in the artisanal trade than elsewhere; second, that it will be beneficial for the republic considering the wide interest in Russian handicrafts abroad (one of the advocates of such an argument is Comrade Anatoly Lunacharsky, who endorsed in *Izvestia* the speech of the most reactionary Russian architect – the 'academician' Ivan Zholtovsky).[6]

I ought to point out straight away that the fusion of art and artisanal production is not only difficult, but also quite impossible. And here is why: our epoch does not have a single artist who could engage in this kind of production. The left are understandably repulsed by it, and the right, or the 'depicters' – i.e., people who cannot contribute to 'life-building' but only know how to depict, which means that they are useless and even harmful to production, or stylizers such as Viktor Vasnetsov,[7] i.e., people who fake 'folk art' and therefore are useless for being the engines of production, for animating, reviving production – are people who will come to the artisan offering him (or his ancestors, as the modern artisan is only imitating them) forms that were stolen from him and remodelled to fit the taste of the intelligentsia.

To search for artists among artisans is a hopeless task; they exist, of course, but they are either inveterate 'rubber stampers', or upstarts who have turned up on the city road, adventurers who have broken away from their organic trade; their artisanship is artisanship under the influence of the

6. Ivan Zholtovsky (1867–1959) moved from a quasi-Constructivist style to neo-classicism and in the 1940s became one of Stalin's favourite architects (eds).

7. Viktor Vasnetsov (1848–1926) was a painter of Russian mythic and folkloric themes (eds).

Impressionists, or the Cubists, or the Futurists, in other words, degraded artisanship that has capitulated to the city.

The defenders of artisan production point to the great advantage of the artisan industry as an export potential, but here, too, it is important to take into account that the long-term exploitation of this type of export is doomed to failure: the demand for the Russian artisan is a demand by the invariably sated foreign bourgeoisie for a 'rarity', an exotic gastronomy. A towel embroidered à la russe, which is a source of pride for some Parisian lady, is no different socially to an Eskimo in a cage, exhibited for money in European zoological gardens. And Russian artisan production cannot, for understandable reasons, depend on consumers from the working class, peasantry and urban petty and middle bourgeoisie of the West.

Finally, it remains to point out that the cultivation of artisan art is nothing but the cultivation of artistic, and more specifically, archaic-artistic nationalism: all of these 'roosters and barrels' have outlived their time. The productive development of art in our age is accomplished, and can only be accomplished by other means.

The Art of Commodity Capitalism

In the time of the guild system, the artist-craftsman was distinguished from the regular craftsman not because he treated objects in a special way, using methods independent from production skills, but because he was a more qualified worker than the rest. The concept of artistry was almost synonymous with the concept of the highest qualification. The artist was *more skilled* than others (and it is from this that the very

word 'art' is derived);[8] he was an inventor, innovator, gifted craftsman and his creations were valued more than those of others because they were made in the best way possible. In the fifteenth century, for example, the prominent Florentine sculptor Luca della Robbia (bourgeois scholars are casting him now only as a specialist in sculpting Madonnas) was celebrated in all of Italy for his first-rate clay pots.

The artist processed materials that were integral to the mode of life of his times and gave them forms that were socially practicable for everyday life during that time.

The situation changed significantly with economic development. I mentioned earlier that under the influence of merchant capital and its exploiting tendencies towards the guilds, artists were forced to move to the production of luxury objects. I will explain now the results of such a shift.

A person with all of his habits and tastes is trained in a social-labour practice, which for one reason or another turned out to be inevitable and the only one for him. As long as the artist could engage in all crafts, he viewed his specialization only as a special ability to make things well. But as soon as his sphere, i.e., the area of his specialization, was narrowed down, for inexplicable and imperceptible reasons, to only a few crafts, he began to think that only those crafts were characteristic of art. People gradually forgot that the artist once engaged in all crafts, and they began to think that the most valuable crafts were luxurious. The artists themselves slowly unlearned how to work with a whole range of materials, which now seemed to them contemptible and not possessing any artistic merit. They became so used to working with only a few types of materials that when they had the opportunity

8. In Russian, art is 'iskusstvo'. The adjective 'iskusny', from the same semantic core, also means 'skilled' or 'skilful' (eds).

to work with other materials, they applied the same methods that they applied to 'luxury' materials, i.e., they defaced and despoiled the objects.

All materials were divided into 'beautiful' and 'non-beautiful' materials: marble was juxtaposed against granite, bronze against iron, ebony against oak, velvet against cheap cloth, and so on. In other words, the new forms of artistic production also determined new artistic tastes, created a new aesthetic.

This aesthetic was, of course, deeply and thoroughly class based.

The new artists began to work for the big magnates of capital, the financial and merchant kings of the society of that period, i.e., for the class that did not produce, but owned and consumed objects. Thus, the artists were irrevocably separated from the guilds, organizing their own independent corporations under the material and administrative patronage of the high bourgeoisie (academy of arts). It is true, though, that in the beginning these corporations admitted a few ancillary crafts (saddlers, tailors, etc.), but by the seventeenth century, the last of the corporations, the Venetian school, excluded forever all 'non-artists' from its membership. And this led to an extraordinary fact: the artist-producer was cut off from production and lost the ability of being guided in his creation by production skills. He began to subordinate the artistic treatment of materials not to the principles of socio-technical practicability, but to the consumer interests of the mercantile oligarchy. He became a member of bourgeois society, and his tastes coincided with the tastes of the bourgeoisie. And those tastes were dictated, first of all, by the new form of artistic production and, second, by the social position of the ruling bourgeoisie. I have already discussed the first factor that conditioned the selection of

'canonized' (sanctified), presumably 'aesthetic' *materials*. The second factor, complemented by the first, abruptly changed the *methods* of the artistic treatment of these materials, and, consequently, the *forms* of the objects.

And here is why.

Artistic production existed only as the production of the means of consumption; in other words, artistic production organized the materiality of everyday life. Art, before it moved into the narrow sphere of 'expensive' artefacts, was able to – and did – organize the *everyday*, which grew out of constant social-labour relations, the forms of which were subordinated to and tested by social needs.

But as soon as art became a brilliant and rare exception, it had to leave the realm of everyday life: the artistic material was too expensive to be worn out through incessant use, while the art forms were too rarefied to satisfy the varied needs of everyday life. Thus, the sphere of the application of artistic craft became extremely narrow: 1) it only included the everyday life of the high bourgeoisie; and 2) it excluded the common, everyday way of life.

What was left?

The everyday life, inherent only to the ruling, exploiting classes: the everyday life of ceremonial, ostentatious display, demonstrating class supremacy and power. Artistic production began to serve the requirements of precisely such external display. The significance of the change that took place in this regard can be formulated in the following way: now artistic production was governed not by *socio-technical* tasks, but by *socio-ideological* tasks; the artist-productionist turned from an organizer of objects into an organizer of ideas, turning the object into a 'bare' medium, i.e., he introduced goals into the

material process of production that were completely alien to this process.

The result was inevitable: the artist began violating the material and forms of objects for the sake of his own tastes and those of his masters. The aesthetic became socio-consumerist, searching in the forms of objects not practicably expressive constructions, but splendour, brilliance, inner effect, i.e., obviously subjective properties. These subjective properties were now imposed upon objects, independent of their purposeful qualities and materials and everyday life.

So, for example, the already famous Michelangelo – who for unknown reasons has acquired in our days the label of a proletarian 'family member' (see comrade Lunacharsky's speech at the Second All-Russian Congress of Proletkult),[9] but who in reality is the first great decadent in the art of life – even Michelangelo was already twisting and turning the balustrades of his stairs in the name of so-called grandiosity. This was possible only because *from now on objects were to satisfy the requirements of the eye, not the requirements of everyday life*. Tables, chairs, drapery, holiday clothes, 'bread-and-salt' dishware, decorated ladles – were no longer usable, but existed to be marvelled at, to be admired. Reception halls, private apartments and vestibules assumed the appearance of museums and exhibitions, and it is not surprising that artistic objects were soon hidden behind glass – i.e., they were killed

9. In the speech, which he made in November 1921, Lunacharsky defends the legacy of classical culture against the attacks of the Futurists. Arvatov was present at the conference, and spoke immediately after Lunacharsky. In his talk he defends the aims of Proletkult and the need to develop a proletarian point of view on the classics. The talk is published in his collection of articles, *Iskusstvo I klassy* [*Art and Classes*], GIZ, Moscow and Petrograd, 1923 (eds).

as objects, being turned into 'bare' visual forms. Later, we see the emergence of special museums of artistic objects: the artistic object had finally left the realm of everyday life and therefore no longer existed.

The influence of these new conditions on the *forms* of objects was, of course, deeply perverting.

The artist was wasting material as he pleased; it never occurred to him to think consciously of the economy of the material. He was not only wasting material (for example, absurdly bent table legs), but also wasting his own labour energy: indeed, how many hours of diligent and painstaking work were spent on shaping, for example, metal in the form of lace. The artist treated stone as he would treat wood, wood as fabric, metal as stone, fabric as metal, and so on. He was no longer interested in the construction of the object, but rather its external form.

The further the process of the isolation of artistic craft progressed, the more the form of objects became separated from the technical treatment of the material.

They eventually began to make the legs of chairs in the shape of paws, door handles in the shape of lilies, book covers in the shape of grottoes, i.e., they completely perverted the essential meaning of each production process, instead of converting the elemental forms of nature into socio-utilitarian forms, they began to model socio-technical forms after the forms of nature, copying their external appearance and forgetting that this appearance is the result of an organic structure (anatomical features of animals, flower parts, geological formation of caves) that has nothing in common with the construction of these objects (the static function of the wooden prop, the handle as a convenient place for the

hand when opening or closing doors, the folio that preserves the book and displays its title).

They made furniture on which it was impossible to sit comfortably without risking breaking it, clothing that hampered movement, floors on which it was unpleasant to walk, because the artist had painted a lake with goldfish on the surface, and so on.

Even nature, having the misfortune of being subjected to the pull of 'creative urges', is obediently smoothed under the pompous etiquette of some royal court. And the cheeks of the Viscountesses and Marquises are decorated with beauty marks with the help of the subservient artist, who has turned his art into a universal cosmetic.

The Artistic Manufactures of Monarchic Absolutism

The age of manufacturing capitalism created large bourgeois-feudalistic monarchies with nobility at their head. Social production finally became production for the market, while the remnants of the socially organized everyday life gave way to the individual-familial everyday life.

There was no role for the artist-craftsman here: craft could not compete with manufacture while the path into manufacture was closed. The bourgeoisie was not, and could not be, interested in artistic inventiveness. Bourgeois organizers of production cared only about the quantitative side of production (maximum economy, processing and practical usability). What is more: manufacture squeezed craft out and became the commanding form of production to the point that, first, the overwhelming bulk of market production was provided by manufacture, and craft was consequently left with a narrow circle of consumers; second, craft had to align

itself with manufacture and lower its quality, in view of the higher cost price of craft production; and finally, craft had to produce objects of consumption that would satisfy the market, meaning, it had to copy the forms of the new market overlord – manufacture. All of these conditions made it impossible for the artist to operate in manufacturing or the craft industry.

In addition to this, the old commissioner of art – the city – was gradually receding. The heads of the cities now were state officials; the collective way of life of the previous community had disintegrated; there was nothing left to organize; and the artist, who once was the organizer of everyday life, had no direct connection with it anymore. He was confronted by the new ruler of society: the spontaneous, indifferent and faceless market with its almighty powers of conformity.

Only a small island of organized everyday life remained: the royal court, which preserved the traditions of feudal aristocracy, regulated its social existence in a planned manner and therefore needed the conscious material formulation of that existence, i.e., art. Apart from this need, there was also the opportunity of attracting huge monetary resources, without which artistic manufacture was impossible. And indeed, since this type of production – considering its extreme costliness and therefore inability to compete with regular manufac-turing – could not count on mass-market sales, since it was unavoidably becoming singular and had to move into the production of unique luxury objects[10] – there was no point in expecting any profits from it. Artistic manufacture became subsidized manufacture; it was maintained by the state treasury; while its social significance was limited to serving the ruling feudal elite.

10. Or 'unicums'. In the Russian edition, there is a transliteration of the Latin 'unicum': unique objects (eds)

At the head of this royal artistic production were the court artists.

There had been court artists before, in the epoch of craft production, but now their position in the production process had changed drastically: if craft, i.e., individual technique, had allowed the artist to be both organizer and executor at the same time, now, in the collective production of manufacture, the direct participation of the artist had to cease. He became only the organizer of the production process; as long as manufacture preserved handicraft, the material collaboration between the artist and his large cadre of assistants, masters and apprentices was possible. However, the creative designs of the artist incurred colossal changes. In the epoch of mercantile capitalism, the artist was pushed out of the social division of labour, but technically he was no different from any other producer of material values. Now the artist was eliminated from the technical division of labour as well. If in the first case the consequence was the violation of the material and the separation of the material from form, in the second case it was form that triumphed over the material. Personal taste began to dictate social production. The artist had to consider the consumer's subjective appraisal rather than the quality of the object – he was not building, but drawing sketches, concocting decorations, patterns and ornaments.

It is true, though, that the taste of the artist was not yet completely arbitrary. The artist, as I have pointed out, served the feudal aristocracy and subjected his will to the aristocracy's needs. From a closer perspective, however, those needs were deadly for the artist.

The feudal aristocracy of the early manufacturing period was a moribund group of semi-parasites; its organizational, socially-necessary functions were minimal. The royal court

was increasingly becoming a burdensome appendage to the state; its everyday life was not socio-organizational, but that of an idle camarilla passing its time in merriment. Such a way of life could not involve the pursuit of any utilitarian tasks, as its sole purpose was to demonstrate class domination. Everyday life was organized solely for the purpose of outwardly elevating and exalting the dominant class over society. In other words, everyday life was subjected to the rules of etiquette, the parade-ceremonial – it was form for the sake of form, splendour for the sake of splendour, naked visual pleasure; an aesthetic corruption of its own kind.

The only organizing force, the formal pivot without which no style can be imagined, was the hereditary feudal tradition, which degenerated from some practicable ritual into ostentatious decoration. The weight of artistic production naturally shifted to the realm of ornamentation. Artists made a name for themselves by inventing wall hangings (tapestries), laces, bands, ribbons, porcelain dinnerware, furniture fabrics, cuffs (*manchettes*), hoop skirts, ruffs, etc. These inventions were still possible because artistic production and social production were based on one and the same manufacturing technique. Technical progress, which had a place in social production, and impelled by market competition, was immediately employed in artistic production. This was the only basis of evolution of the style back then: it is impossible to think of any kind of artistic-formal development without technical creation. But since in this case technical creation was introduced from the outside, and the artist was only left with the creation of external forms, the discord between the form of the object and its construction was not only the consequence of the organization of artistic production of that period, but also its inevitable condition. In the same way that

feudal aristocracy had become by the end of the eighteenth century a mere decoration of the state – which covered the structural breakdown of the country from incautious eyes with gold – its art was a decoration of objects, the social-everyday life significance of which was almost equal to zero, while technical construction amounted to a rabid, anti-utilitarian waste of material.

The bourgeoisie either resented or slavishly and tastelessly copied the aristocracy, which at least had one merit: its inherited rigour and restraint in taste.

The Industrial Revolution at the end of the eighteenth century, machinic technique and the reign of the bourgeoisie, put an end to this last trump card of artistic production. This marked the advent of the age of stylization and applied art.

Applied Art in the Age of Machine Capitalism

Artistic manufactures continued to exist in the nineteenth century as well, but in a completely different way. First, their numbers had diminished: the circle of consumers had reached its lowest. Nevertheless, every state considered its duty to promote the 'flourishing' of degraded art and maintained two or three manufactures for this obviously pretentious purpose.

At a time when social production was leaning more and more towards the progression of machine technique, art – 'consecrated' art – continued to content itself with the backward techniques of manufacture. This was due to the fact that the machine had finally eliminated the artist-craftsman from the technical process of the treatment of materials, and the organizer of the new factory could be anyone but the artist. In places where art still pretended to have organizational functions, it had to comply with manufacture; no other

technique was acknowledged. The machine was declared to be the destroyer of 'free' creation.

The results manifested themselves very quickly: artistic manufacture turned out to be incapable of evolution, of even the preservation of its previous level of skills.

The fact of the matter is that any kind of formal progress is a function of technical progress. Once manufacture became a hothouse plant, once there was no force to push it towards technical perfection, and once technical evolution moved into the sphere of mechanized processes of production – manufacture could not become anything but stagnant. It was running helplessly on the spot, employing eighteenth-century techniques in the nineteenth century.

Based on this alone, mass production – the sole condition of the flourishing of enterprises in a developed capitalist society – was impossible. But no matter how small artistic production was, it could have been successful if it had pursued concrete social tasks. However, it did not and could not have had any such tasks. Manufacture had been serving the strictly defined, fixed, everyday life of feudal aristocracy. By the nineteenth century this everyday life no longer existed. The Great French Revolution wiped out the last vestiges of a collective way of life.

The states were now governed by bourgeois parliaments, and monarchs; like their ministers and bankers, they had become part of the bourgeoisie. Hereditary traditions disappeared, the everyday became anarcho-individualistic and its forms of decoration (it is senseless, of course, to talk here of a constructive organization of life) depended now upon the personal subjective taste of each consumer of art.

Thus, workers involved in artistic manufacture could no longer be directed socially and objectively by either the

production factor or the needs of everyday life. In other words, artistic manufacture lost its opportunity to build independent forms rooted in its own environment; it tore away from society and hung in the air. It supplied artefacts to large factory owners, the representatives of the dying landed nobility, produced for export for abroad, filled the museums and catered to the whims of stock-market upstarts who wished to surround themselves with 'chic'.

The forms of its production were no longer being determined by technical or social-everyday life tasks, they depended solely upon the tastes of artists who, almost accidentally, had gained access to manufacture. Artists became completely external to production and occupied themselves with a concoction of all possible forms. But since they could not create their own independent, organic forms, they had to borrow forms from past, organic epochs and refashion things according to their own production. They began to produce seventeenth-century-style carpets, antique-style vases, Renaissance-style furniture, and so on.

Ending up rather arbitrarily in private residencies, these objects were removed from everyday life and turned into exhibition artefacts. If, during the period of monarchic absolutism, artistic domestic utensils gave a permanent articulation to everyday life, now, detached from the praxis of life, they were converted into objects of luxury, 'rarities' that existed not for permanent use, but for appearance only. Vases were displayed in glass cupboards, plates were hung on walls, carpets and fabrics were kept in chests – to be brought out and used only on festive occasions. It is not surprising, therefore, that manufacture shifted more to making so-called 'trinkets', the name of which alone attests to their role in bourgeois

everyday life.[11] Art became a sheer mockery of the meaning and purpose of production, of human labour activity.

Two or three manufactures in the country with a quantitatively insignificant level of output could not, of course, meet the requirements of bourgeois society. Meanwhile, the aesthetic needs of bourgeois society continued to grow and the only way to meet the demand was through mass production based on new machine techniques.

What pertains to the great mass of the petty bourgeoisie with its everyday traditionalism and conservatism is that its needs were organized according to 'customary' models: flowers on saucers, swallows or peas on shawls, roses on curtains, etc. In order to secure buyers, capitalist industry had to take this taste into account. Factories hired special master painters who produced patterns according to the standard clichés established from old, stagnating devices. There could be no talk of artistic progress here.

But, there was yet another significant layer of society, the middle and high bourgeoisie, who demanded of machinery a greater range of artistic qualities. Every respectable bourgeois wanted to have 'beautiful', 'fine' objects in his apartment; every bourgeois strove to surround himself, in addition to ordinary, 'simply useful' objects, with objects that brought 'pleasure' and 'enjoyment' for which he was prepared to pay significant amounts.

It goes without saying that the chief aspect was the cost of the material: golden bracelets, rings, key chains, earrings, precious stones and other articles of luxury became the objects of more elaborate production in the age of capitalism.

11. The Russian word *bezdelushka* (trinket) literally means something idle, not meant for work (trans.).

The other criterion was the 'beauty' of objects, and by 'beauty' the bourgeois meant the forms on which he was raised. And since the aesthetic taste of the bourgeoisie was organized, first, by museums of antiquities and, second, by exhibitions of paintings or sculptures, the 'beauty' of capitalist artefacts could not but become a contradiction of the tasks of production and the general system of material everyday life.

And indeed it was so.

The organizers of machine production were proprietors and engineers; the former were interested in profit, the latter in technique. The forms of products were not determined by anyone and were generated spontaneously. In cases where the capitalist producer was required to introduce 'beauty' into production, he had no other option but to invite an artist to create this beauty. But at this point there were no artists left who had grown up in production or were at least acquainted with it. The dominating form of art had become individualistic, easel art (painting, sculpture). The artist had turned into a solitary craftsman who worked for the market and created non-utilitarian, anti-production objects; his creative work bore very little resemblance to the social process of production, just as a watercolour landscape hardly resembles a steam engine.

Coming to production from the outside, brought up individualistically, and used to depicting, not 'life-building' – such an artist could offer nothing but external decoration of ready-made objects; he simply 'applied' form to the object (hence, the name 'applied art'), regarding the object from the height of his 'inspirational' grandeur. He painted miniature landscapes on vases and decorated dishes in 'Impressionist style' (i.e., masquerading under the guise of painting). The artist treated the object as if it were the canvas of his painting. Practicability, the purpose of the object, and its technical

demands, remained beyond his field of vision. Form to him was an end in itself, and his own individualistic taste was the governing law.

When the applied artist contemplated style, the whole question came down to covering the surfaces of different objects with identical patterns (little crosses, squares, circles). Ultimately, if he had to enter production (the bourgeoisie always considered this realm of activity as 'low' – depictive painting was seen as 'authentic' art: illusion was valued more than reality), he always preferred artisanal production, where at least he was not intimidated by the requirements of technical qualification. In contrast, the machine preferred to operate without extraneous, externally imposed tasks. From an organizer of human productive forces, art had turned into their impediment.

Technical Intelligentsia and the Birth of New Forms

At the end of the nineteenth century, capitalist society entered a new historical phase. The enormous growth and concentration of capital, the expansion and improvement of global communications, the nationalization of transportation, the emergence of trusts, and the establishment of monopolies within national borders – all of this was a manifestation of a gradual and continuous collectivization of human productive forces. Everyday life had to be inevitably collectivized alongside the collectivization of production. Huge industrial cities arose, in which large masses of the proletariat were concentrated. The labour of the intelligentsia was turning into collectivized labour; the banks, industrial institutes, governmental and municipal establishments, trade enterprises, technical laboratories were all slowly turning into collectivized

organisms similar to factories. A growing realm of everyday life was being wrenched out of the private, individual sphere and becoming socially organized. Socialization began to infiltrate, first of all, the sphere that dealt not with the private relations, but with the social-labour relations of people, i.e., the sphere of so-called productive consumption. This included every kind of communication between people and consequently the whole realm of the organization of so-called conditions of labour: transportation, telecommunication, radio, sewage, production clothing (*prozodezhda*),[12] etc., – the whole way of life, which unified people and replaced the functions of individual character with functions of social character.

The production of the elements of this new material everyday life could not, of course, remain on the same stage of private economic development, could not remain anarchic-accidental. It required not only minimal organization of production, but also its strictest normalization. The trust that served its own railroad had to consider now the concrete needs of everyday life, and not the market (this became possible due to the fact that, first, the main competition was in the external markets and, second, it was chiefly based on

12. The concept of *prozodezhda*, or production clothing, was first introduced by the leading Russian Constructivists Lyubov Popova and Varvara Stepanova in 1922 in their design of theatre costumes. As Stepanova wrote in her manifesto 'Kostyum segodnyashnego dnya – prozodezhda' [Today's clothing – prozodezhda] in *LEF* (1923), 'The aesthetic elements must be replaced with the process of production: the sewing of the costume. Instead of sewing on decorations, the revealed stitches will give form to the costume. There are no more blind stitches used in embroidery, only the industrial stitch of the sewing machine: it industrializes the making of the costume and frees it from the mysteries of the charm of individual, handmade work of the tailor' (trans.).

capital export rather than the export of goods); from now on it pursued not only the goals of an exchange order but also of a consumerist order: economy, convenience, maximal flexibility, portability, universality of objects – this is what preoccupied the new organizers of production. The same happened when the trusts were designing entire cities for workers and civil servants, organizing their own shops, offices, etc., or, when work was commissioned by governments or by city municipalities. The products were produced directly for the consumer, and a collective consumer at that. In this new realm, production was faced with technical-inventive tasks: if before inventive creation in engineering limited itself to the means of production (machinery, etc.), now it had to take over the invention of the forms of everyday life, and the kind of everyday life which did not have any traditions was completely new, and therefore demanded the emancipation from any repetitions or external additions, i.e., it demanded a revolution of material forms.

But there is more. The sphere of productive consumption is distinguished, above all, by strict regularity of functions. The forms that appear as a result of the collectivization of everyday life also possess this kind of regularity. There can be no individual arbitrariness or personal taste here – everything is determined by the objective tasks of building independent from individual consumers or individual producers. Let us take, for example, contemporary urban restrooms, bathrooms and shower rooms; they were organized either archaically or fussily/arbitrarily until every apartment incorporated these forms into their design. As soon as large multi-apartment building complexes unified the sewage system of the buildings and then of the entire city, and the production of restrooms became part of mass production – we saw, first, the unification

of forms and, second, their perfection: the material changed, the principle of purposefulness came to the fore, an advanced technique was implemented, and so on. The forms became contemporary and strictly tempered; they did not leave room for stylization or aesthetic violence against the material in the name of ostentatious luxury. In the process of invention the engineers had to let go of their subjective habits, reject aesthetics; they had a specific task in front of them, and they had only one method – machine technique; form was achieved as a result of this.

This was true in all areas where the needs of society were collectivized and productively limited. It is characteristic, for example, that contemporary dishware was created as kitchenware (made of aluminium), i.e., in the sphere of productive consumption, and appeared for the first time in large hotels and restaurants, i.e., in places of collective consumption. If we were to look at the new and organically independent accomplishments in the contemporary furniture industry, we would have to point out the automobile cabins and railway wagons, the cabins of transatlantic steamships, the cabins of airplanes, and finally the offices of industrial enterprises.

The production of clothing is at an especially interesting juncture: the bourgeoisie had created chaos in clothing design and the so-called fashion industry. And only the newest forms of productive consumption were able to elaborate an independent style of clothing. There are, of course, all kinds of *prozodezhda*: the driver's and the pilot's suit, the electrician's jacket, the athlete's costume, etc., The dictating forces here were not people, but objective purposefulness and advanced technique. It is extremely curious that the driver and the pilot both acquired their clothing in the army, i.e., in a collectiv-

ized organization. It is true, though, that before the Great War, army uniforms were colourful and stylish, indeed, as in peacetime, everyday military life consisted of little more than parades and chic dandyism. But as soon as the war broke out, military life was subordinated to the fatal grip of practical combat tasks, and a new style was born – the style of 'khaki' pants and the 'French' military tunic.[13]

I should also mention telephones, radio receivers, electric armatures, electric burners, and so on.

It is the same everywhere: style begins where personal arbitrariness ends, and conversely, style ends where personal arbitrariness begins. This is why the bourgeois artist-individualist was running away from the machine; this is why he hated modernity, seeing nothing in it besides 'soullessness'.

However, the revolution of the production of the object carried out by the large industries was far from being complete and finished. The enormous sphere of so-called pure everyday life remained untouched. The problem is that the engineers who created the abovementioned forms rather spontaneously, were simply subordinate to the tasks of production, but as soon as the same engineers ventured beyond the boundaries of specific consumer functions, as soon as they took over the production of objects from the private sphere, say, objects of everyday life – their aesthetic upbringing manifested itself immediately along with all the remnants of outdated forms and pseudo-artistic 'decorations'. So, for instance, many of the modern electric chandeliers are deplorable copies of eighteenth-century candelabras.

13. Named after the British Field Marshal Sir John French (trans.).

There had to be another revolution – a revolution among the legislators of aesthetic taste and among the artists. Besides, humanity had to be charged with the tasks of the universal collectivization of society and, therefore, of everyday life. Both of these came with the Russian Proletarian Revolution of 1917.

Architecture

At first glance, architecture was supposed to evade the noxious breath of the capitalist sirocco. But here, too, the grandiose and spontaneous rise of cities and the speculative race for profit transformed our streets into stone corridors, on the sides of which stretch rows of the box-like houses of modernity. London, for instance, is rather naively and openly divided into quarters for the affluent, quarters for the middle bourgeoisie, and quarters for the workers. In each quarter the streets are comprised of completely identical buildings with identical façades: all have the same standard size.

The house owner now needed an engineer, not an artist. Architecture became a subject of study at art academies, while engineering was taught at polytechnic institutes. This process had already begun in the era of urban economy. Late Gothic architecture, which had completely forgotten those times when cathedrals were built by a collective of masters, fell into the hands of art specialists for whom the measure of artistic quality became the maximal external effect, the god of the new society.

In the times of Louis XI and Louis XII, the inventive artists, who were not so much builders as decorators, tried to decorate the wide walls of the cathedral with fashionable ornaments. One beautiful day they mixed the Italian

arabesques with the fantasies of the flamboyant Gothic style, after which the antique system of ornamentics became wholly accepted, for nothing hampered them from drawing pilasters on counterforts or carving Corinthian capitals to support the arches of the vaults (Louis Hourticq).[14]

The early Renaissance, headed by the ingenious Italian architect Filippo Brunelleschi, was able to create independent forms in the area of constructive elements in architecture (*rustication*); the rest of the history of architecture simply represents the reworked combination of antique and other motifs – a moderate and stylish reworking, while the aristocracy preserved its hereditary traditions, and an eclectic and often tasteless reworking after that. But it is curious that even in the first case everything new was limited almost exclusively to decoration. Having unlearned how to build, artists began to decorate, and it is only reasonable that these decorations turned out to be merely external, merely superficial: such are the Baroque cartouches and Rococo shells and C-scrolls. And isn't the wig, the obligatory head decoration of the period (the seventeenth and eighteenth centuries), an interesting sample of 'scenic' art?

And they covered the buildings with similar 'wigs'. The rough masonry of the walls, where every stone was soaked in workers' sweat, affronted the refined aristocracy of the eighteenth century, and the framework of the construction was shielded from the delicate eyes of the residents with a screen of patterns, mirrors and paintings. One could do anything

14. Louis Houticq (1875–1944) was a French art historian, who wrote extensively on Poussin, Watteau and Ingres. Arvatov does not supply a reference. The quote most likely is from the Russian translation of *France* (1914), *Franzia*, Esteticheskie Problemi, Moscow, 1914.

with the screen: it no longer depended on the construction of the building. Now it was possible to break through the walls with gigantic landscapes, visually expanding the halls of the royal palaces, and conversely, to cut the corners of boudoirs to achieve an exquisite miniature effect with thousands of cast patterns. Finally, it was possible to furnish the room with mirrors to achieve a greater brilliance, knowing well in advance that nobody would live in such a space.

The reign of the bourgeoisie delivered its final blow to architecture with a last sad smile – the Empire style. But history made even this last smile twisted and pathological. The Empire style emerged not as a result of socio-technical progress; it appeared as a consequence of a new ideology. The young revolutionary bourgeoisie, along with the dying feudalistic aristocracy, as strange as that might sound, turned simultaneously to the heroic periods of ancient Rome and Greece (and partially Egypt). The bourgeoisie found in these periods the prototypes for its grand plans, while the aristocracy searched hopelessly in the distant past for content to support its emptied and doomed forms of ghostly rule. This is why the style of the Great French Revolution was, in essence, a development of principles from the epoch of Louis XVI, and this is how Robespierre's friend, Jacques-Louis David, could become Napoleon's court painter. The Empire style was created as an imitation of the past, and its creators were completely divested of any kind of self-sufficiency.

This is how 'passéism' gained a foothold.[15]

15. The patriarch of bourgeois aesthetics Johann Winckelmann wrote, playing with words: 'Der einzige Weg für uns gross, ja wenn es möglich unnachahmlich zu werden, ist die Nachabmung der Alten' ('The only way for us to become great and, if at all possible, inimitable, is to imitate the ancients').

An architect who was not bound by a collective practice, an individualist living and following his own desires, could not create anything for contemporary life. All the more so because, in the nineteenth and twentieth centuries, artists were invited to build only lavish, typically expositional structures, and since they did not have their own organic style, they designed temples modelled after the Greek style, palaces after the Roman style, and museums after the Renaissance style. And all of this was installed haphazardly, inorganically, amid the amorphous conglomeration of existing buildings.

Style degenerated into stylization, which found its patronage and refuge in the academy. This is where, for the lack of a better choice, the academicians conserved the canons and clichés of the buried centuries, mummies instead of live creations, ossified forms, the purpose of which was to serve as 'ideals of beauty', criteria of 'authentic' art. In this blind veneration of antiquity, the architect of capitalist society became so stuck in aestheticism that even the construction of buildings in his hands became something like 'pure' art, torn from the busy flow of life. And when sometimes he is drawn to the monumental style, we inevitably encounter the 'Egyptian' projects of French sculptor Jules Dalou, or, in our own time, we come across the 'daring' attempts of the uninspired authors of the Leningrad crematorium, the construction of which has fortunately not yet begun.

In the meantime, gigantic developments in metallurgical technique in recent decades, directly invading our lives, have produced unprecedented miracles with reinforced concrete. But even the Paris Exposition of 1900, with all its innovations, could not awaken architecture from its slumber. The artist-academician has buried his head in the sand and dust of the archival centuries like an ostrich; he rejects the iron

railroad bridges, platforms, markets, skyscrapers and factories. In his eyes, all of this is hideous engineering: he cannot live without his beloved columns, pediments and pilasters. He uses contemporary technique to cover stations with tombstones à la russe (see the Yaroslavsky Railway Station in Moscow) or to decorate bridges with 'stylish' lanterns (Troitsky Bridge in Petersburg). The engineer also falls under the influence of the corrupt tastes of his foe, the artist; perhaps the best example is the Eiffel Tower, built according to all the rules of canonized symmetry and serving no purpose except as an accidental cafe for foreign *flâneurs* and the occasional international radio broadcast. What is interesting here is that if technique wished to create a purposely-artistic work, it could not (even in the hands of an engineer) go beyond the boundaries of 'pure' art, because the repository of the artistic worldview of the bourgeoisie stood in the way.

The Eiffel Tower was conceived solely as a demonstration of the power of the newest capitalist technique without a single thought of its practical usability. Whenever this technique left the sphere of price catalogues and exhibitions and lent itself to realistically necessary architectural building, it inevitably became the object of financial speculation, demanding, first of all, maximum profits, for which capitalist society was ready to sacrifice everything, including the principles of technical and everyday life practicability.

The most characteristic creations of the newest architecture, reflecting the latest technical achievements, were the famous American skyscrapers. And here is why. The exorbitant increase in land rent led entrepreneurs to find a way of squeezing as many people and offices into as little space as possible; this is how the floors kept growing and growing, subordinated to the only directive: to economize on expensive material. Stone boxes

were replaced with metal boxes, in which humans were buried alive. It is obvious that the artist could only turn away from such a 'creation' in horror and fear, once again transferring his disgust of everyday life forms to the means of their realization, continuing to reject the new technique only because it was unsuccessfully applied in practice.

When philanthropic aspirations finally took over the consciousness of the artist, he was only capable of inventing reactionary projects such as the city gardens, the peaceful idyll of one-storey wellbeing, which he painted in the form of English cottages or Scandinavian family houses that had outlived their time. He did not understand that the productive forces of our time had outgrown the individualism of the petty bourgeois townhouse, but he could not use the contemporary industry for his purposes, and the initiatives of the architects were confined to the construction of so-called workers' settlements, to whom the bourgeoisie yielded with the pleasure of hypocritical benevolence the right to a 'family idyll'.

Finally, I ought also to mention the so-called 'Modern' style to conclude the question of architecture in capitalist society. In a realm of architecture limited to plastering and coating, in a realm of 'applied art' drawn to 'comfortable simplicity', which signalled nothing more than artistic helplessness, this 'style' is already dead, and if we are to discuss it, we should do so only as an example of the decadence of bourgeois building, by no means 'simple', but horribly mannered. The best proof of the meaning of the 'Modern' style is in its name: without introducing any constructive principles, it could only say about itself that it was 'contemporary'. This, of course, did not stop it from becoming old after some five or six years. Today, even former admirers speak of it with derision and contempt.

2
Easel Art

The Origins of Easelism

Towards the middle of the nineteenth century, artistic architecture, i.e., architecture that aimed to satisfy the artistic tastes of its users, had degenerated completely. Marx wrote:

> [I]n the developed capitalist era, when on the one hand masses of capital are concentrated in the hands of single individuals, while on the other hand associations of capitalists (stock companies) appear by the side of individual capitalists and the credit system is simultaneously developed, a capitalist contractor builds only in exceptional cases for the order of private individuals [i.e., directly for the consumer – B. A.]. He makes it his business to build rows of houses and sections of cities for the market ...

And consequently:

> If a man wants a house, he selects one from among those built on speculation or still in process of building. The contractor no longer works for his customers, but for the market. Like every other industrial capitalist, he is compelled to have finished articles on the market. While formerly a contractor had perhaps three or four houses at

a time building for speculation, he must now buy a large piece of real estate (which, in continental language means rent it for ninety-nine years, as a rule), build from 100 to 200 houses on it, and thus engage in an enterprise which exceeds from twenty to fifty times his resources.[1]

Thus, artistic architecture became a rare exception, losing its connection with 'general-life building'.

Sculpture and painting gradually separated from artistic architecture in parallel with its demise. This was facilitated by the individualism of the exchange economy and technical specialization, which left no room for the previous synthetic union of all the arts. Their divorce was complete by the nineteenth century, affecting sculpture the most.

In the early Middle Ages, cathedrals were erected by collectives of masters who moved from city to city, who were welded together by common tasks, and who, in an organized way, assigned and shared work amongst themselves according to their specialization. The plan of the edifice was discussed jointly; each one of them was a collaborator in a collective project, voluntarily submitting his creativity and its fruits to the collaboratively created unitary organism of the building. Their experiences were identical, and so were the levels of their technique, artistic worldview, social position and so on. The sculptor was one master among many. Moreover, he worked not only within his narrow area of specialization, but also to a certain degree as an architect and a painter. In his consciousness, sculpture was inseparable from the rest of the edifice – it was part of the whole as a constitutive element, just as he, the sculptor, was only a ring in the chain of the human

1. Karl Marx, *Capital: A Critique of Political Economy*, Vol. II, Part II, Ch. 12, trans. Ernest Untermann, Charles H. Kerr and Co., Chicago, 1909.

collective. And if we were to add that his relationship to the material was technical – i.e., that stone, timber or bronze were used according to their properties (his craft had taught him this) – then it will become clear why, in the old cathedrals, sculpture, which depicted the religious ideas of the time, blended so well with the architectural base, why the relief never transgressed the plane of the frame, and why statues technically functioned as columns or semi-columns. This type of sculpture was inseparable from the building, functioning as its constructive element. In its depictive aspect, sculpture shunned most of all anything bluntly individual and rendered only the widely generalized images of God and the saints, following the traditional canons of authoritarian mentality inherent to feudalism.

The development of commerce and the growing importance of the urban merchant class soon made everything, including church architecture, dependent upon the new class, which emerged in the historical arena with two distinguishing features: individualism and competition. The latter affected craft in a most decisive way, evoking in it a tendency towards intensified specialization, which fragmented the once strong collectives as a result of the inevitable competition introduced by the almighty merchant. The rivalry drew in entire cities, turning them into trade opponents; they began enticing the best artists, and there could be no more talk of the old collectivism in art. It became more and more common to bring in a sculptor or a painter from elsewhere because of his fame and expertise. Understandably, such an artist would gradually become alienated from the interests of the collective; now he was more concerned with the effect of his own creative work than with subordinating his work to the harmony of the whole.

This tendency towards individualism in the sphere of technique went hand in hand with other phenomena, pushing the artist towards the emancipation of sculpture and painting. On the one hand, the old generalized images of the gods no longer satisfied the new consciousness: people wanted more concreteness, more 'liveliness', and the sculptor (and following him, the painter), at first clumsily and timidly, then more and more confidently, moved from the hierarchical grandeur of ancient depictions towards attempts to transmit movement, personal emotion, even national everyday life, and local peculiarities.

On the other hand, the artist, who had chosen to serve the powerful men of this world, had to satisfy the need of the merchants, who, having already acquired all the characteristics of parochial patriotism, wished to see themselves in church depictions: the cathedral after all, represented the external expression of their power and majesty.[2] Thus, architectural sculpture and painting, while formally remaining in the realm of church traditions, transformed essentially into portraiture.[3]

2. By that time, the church had transformed from a mere pillar of the clergy to an organizational centre of the urban classes. 'The same citizens who fought together as allies against the privileges of the clergy, now helped erect the towering cathedrals'. 'The official notification of city decrees in the church competes with the purely urban method of promulgation; "The Church Call" (*Kirchenruf*), as it was called in those days, was indeed not a rarity. In many communities this was a regular form of official communication. For example, when a new tax was added, the members of the parish learned about their portion of payment from the church cathedra'. Georg von Below, *Das ältere deutsche Städtewesen und Bürgertum*, Bielefeld, Velhagen and Klasing, 1898.

3. *Ibid.*, 'The famous artists were drawing and painting burgomasters, members of the national assembly, female citizens in their fine dresses . . .'

And this mandated a repudiation of the previous conventions of symbolic depiction, presenting the artist with an unprecedented and unfamiliar task: to transmit the external reality with the utmost precision ('as life-like as possible').

Along with this, the old relations crumbled irrevocably: the correlation of the depictive arts and the constructed edifice was reduced to its decorative appearance. Now sculpture and painting were connected to the building only visually. The sculptor began to work on three-dimensional statues, which were conceived from this point on as independent from the given setting, transferrable to other settings, and easily separable from the wall and the frame. The painter occupied himself with issues regarding perspective and illusion in order to transmit the spaces and volumes of the external world, without considering that such an approach would essentially destroy the meaning of the wall as an enclosing plane.

From here it was only one step towards the complete separation of the once organically fused elements of architecture. This step was made when the market demanded from the individual artist the unrestricted sale of his works to anyone, when church art began to cede its place to secular art, which was not dependent on any particular construction and which bound the artist to the inconstant conditions of the private residence. Besides, the material resources of the individual person who wished to use the gifts of the artist were, in most cases, insufficient for commissioning murals, etc., which is why easel art, meaning portable art – statues or paintings – eventually became the main form of depictive art. The new artist devoted to his individualism grew so accustomed to his studio that he could not renounce the easel; on the contrary, he accepted it fully and whenever he

had to work with an architect, he applied his easel techniques, perceiving the wall or the frame merely as an enlarged easel.

The Degradation of Sculpture

Operating in three dimensions, sculpture is the treatment of a material's surface and is held to be a constituent element of a building or a set of buildings, i.e., of the street, of the square and so on.

This is why in the era of developed city-building, when the city commune in its splendour and 'beauty' was dear to every citizen, despite the internal feuds that ripped it apart, it was patriotic to decorate public spaces with sculptural compositions that had separated from the building and moved temporarily to the square.

But the broad social life that brought about griefs and joys, the fruits of its inspiration and the results of its labour in the street, was gradually disappearing. It was being replaced by a narrow and egotistical domestic way of life.

The advent of the bourgeois state marked the end of direct contact between the artist and society.

As already mentioned, the building of cities was not determined by the free, organized will of the people, but by the impersonal demands of the market. The municipalities, comprised of officials and the state, headed, again, by officials, became the new commissioners of 'street' sculpture. As the street by now had turned into a huge thoroughfare and it was impossible even to dream of any kind of unity of style, sculpture, appearing in the square, began to reveal itself as something independent from the surrounding world, as self-sufficient and therefore alienated. In its depictive tendencies, sculpture either became an official and vulgar demonstration of class

rule like the Sieges-Allee (Victory Avenue) in Berlin and the royal monuments in old Russia or, withdrawing into the artist's studio, it began to serve individual ideology.

But here sculpture found itself in a hopeless situation. Work on objectal[4] material, bereft of constructive tasks and designed solely to depict certain ideas and experiences, could not by itself give birth to organizational methods (i.e., style). Naturalism did not save the sculptor either, chaining creativity to photographic quality. There was only one option left from this situation: to imitate the already established styles or forms of the other arts. So, the sculptor was confronted with either stylization, or aesthetic violence against the material. In either case, this meant a complete severance from modernity, a retreat into archaism, artificiality, unnecessary mannerism, 'the belletristic', 'the painterly', 'the poetical', etc.

In either case, it meant not the creation of new forms, but the observation of 'recognized' clichés, not the subordination of aesthetic concerns to live reality, but the subordination of reality to dead aestheticism.

That is how the academic German painter Theodor Hildebrandt, and the academic Russian sculptor Sergei Konenkov produced their work: by copying antique templates.[5] That is how Rodin in the twentieth century employed the art forms from ancient Egypt to the Renaissance. Freeing himself from *passéism*, Rodin still cannot find an alternative to the devices of academic painting in his work in wood or stone (Impressionist sculpture is a kind of *contradictio in adjecto*). The form and purpose of modern sculpture not only fail to

4. 'Objectal' ('veschestvenny') for Arvatov, means material presence, or the materiality of things in the world and derives from the Russian word 'vestch', a thing (eds).

5. Theodor Hildebrandt (1804–1874), Sergei Konenkov (1874–1971).

complement each other, eventually they begin to contradict each other. It is not surprising, therefore, that sculpture in the twentieth century is in a state of total decadence, slavishly awaiting help from the new achievements in painting (even Cubism in sculpture appeared as a result of Cubist painting).

Painting

Let me move on to painting.

I have already pointed out that easelism (*stankovism*), i.e., the production of discrete paintings, emerged as a result of technical specialization and the subordination of the artist to the laws of a commodity economy. In this respect, the fate of painting in bourgeois society is no different to the condition of sculpture. In other respects, however, the paths of these once sister arts diverged drastically. Sculpture, as we saw, lost its way to independent development for a while; this did not happen to painting. The fact is that after the painter left the realm of real objectal relations (architecture and the material elements of everyday life), he did not have to encounter them any more; unlike the sculptor, he did not have to operate on real materials. This is why, not meeting any real resistance or constructive tasks opposed to the demands of 'depiction' (the aim of the painter, as the aim of the sculptor, was to 'depict' something in a self-sufficient way, derived 'from oneself'), the creative aspirations of the painter were transformed into a single relationship with the depicted phenomenon and could freely flow into one or another form.

The only objection that can be made here is that canvas and paints in painting are just as substantial materials as wood or stone in sculpture. This objection is easily dismissed with an elementary analysis of the art of painting: *paint* for the painter exists as a mere means for working on *colour*, while the canvas

simply serves as the surface on which the colour is applied. In other words, we are dealing here only with a visual aspect. The situation essentially changes with sculpture: the sculptor – the 'depicter', in a sense, also wants to deal only with our vision, but – alas! – the process of sculpting does not allow for that, and the sculptor, whether he wants it or not, or actually, it is beyond his will, is faced with the task of not only depicting, but also 'building'. Herein lies the paradoxical tragicomedy of bourgeois-depictive easel sculpture: you cannot depict without building, and in depicting, you do not know how to build.

I repeat: painting does not 'know' such a contradiction, and this is why it has thrived in capitalist society and produced such rich results, which the contemporary period has offered on the small platter of easel painting. The creative potentials of society followed the path of least resistance in the given situation – the path of painting. We shall see later what this led to, but in the meantime, let's describe bourgeois painting in its typical form – the easel painting.

Paintings, i.e., depictions in colour, existed long before the advent of easel painting. But if Giotto's frescoes served as visual transmissions of Franciscan legends, we must not forget that at the same time they were linear and painterly decorations of the wall surface. Even the iconographic easel craft of ancient Rus or Italy originated from the same decorative assignments, as the icon, attached to a specific place in the temple, was its organic element and naturally could not be imagined outside of it.[6] History, as I have already noted,

6. It was interesting to see how Andrei Rublyov's famous *Trinity* had dimmed, disappeared, become distorted when they brought it to the Moscow exhibition in 1920 from the Trinity Lavra of St. Sergius near Moscow, where it had lived a full and almighty life in its native setting. Conclusion: the old should either be accepted wholly, or rejected, preserving its minimum in the storages of science.

uprooted the painting from its previous conditions without giving it any new organizational basis. The painting, if I may play with words here, became groundless, i.e., easel-based. The significance of this evolution lies in the fact that easel painting, unlike the previous forms of painting, categorically demands its complete independence from anyone and anything; it is not only materially disconnected from the rest of the world, it does not want this connection (connectivity?), for it represents a self-sufficient, self-contained world in itself, reflecting the detached self-containment of its solitary creator. But if the easel painting is a 'thing in itself', it does not necessarily follow that it is a 'thing for itself'. No matter how much the bourgeois artist tried to separate himself from the 'contemptible crowd', he still somehow remained its offspring, and his experiences, his interests and tastes found always and everywhere their perhaps belated, but distinct and eventually favourable response. And it could not have been otherwise: born in society, art lives in society, satisfying its needs, organizing it actively, even if by means of the easel painting.

What were the needs of the newly formed bourgeois society? What demands did it place upon art?[7] According to what has been said before, the new relations of production put an end to artistic creation in the sphere of the 'social everyday'. Disharmonic, 'amorphous' or, more precisely, unorganized forms of life became more dominant; not satisfying anyone, the world of 'objects' offended sensitive minds. It was pointless to talk about the fullness or completeness of emotional experiences. The unity of the concrete disappeared. Art retreated from life. But this led to a very characteristic phenomenon: life rushed towards art, searching in it for a harmony of objects, fullness

7. I am posing these questions only now, because painting reflected the bourgeois possibilities best of all.

of emotions, and unity of the concrete. The intensity and abundance of art was to compensate for the insufficiency of life. The opposite happened: with the artist tearing himself from life and 'despising' it, he inevitably had to compensate for the insufficiency of his 'I' with the abundance of life. Thus, the two supposedly opposite tendencies converged, but in reality they represented a single solution to a single socio-historical problem.

'Landscape', 'genre', 'still life', 'portrait', 'mythological' painting, and so on, appeared as a result of this. Art took the path of depictive, objective reflection ('transfiguration') of the external world and an imagistic concretization of emotional-ideological moments,[8] having renounced everything else and from now on translating into artistic form not the real object, but only the illusory appearance of its 'content' ('painted' person, 'depicted' sea, 'fabricated' lily).[9]

This is why another painter cannot imagine a revolutionary mentality accustomed to the 'views of nature', 'scenes from life', 'psychological etudes', and entangled in the notorious problem of form and content.

Only this can explain how, for example, the first Russian socialist Nikolai Chernyshevsky could dig out from under the pile of centuries the Platonic-Aristotelian theory that all art is imitation of nature.[10] It is not Chernyshevsky's fault, of

8. Let's recall Eugène Delacroix's statement: 'Colour means little if it is not accorded with content and if it does not intensify the impression on one's imagination' (cited in Paul Signac, *From Eugène Delacroix to Neo-Impressionism*, 1899).

9. Marx notes in passing: 'Painted grapes are no symbol of real grapes, they are imaginary grapes' (in Karl Marx, *A Contribution to the Critique of Political Economy*, 1859).

10. Nikolai Chernyshevsky (1828–1889) was a socialist, philosopher and art critic. Arvatov here is referring to Chernyshevky's master

course, but the fault of the bourgeois art forms of his time, the conscious purpose of which was imitation, and through which it discovered its own bankruptcy. The contradiction here is that in practice imitation is impossible and, while striving to imitate, the individualist artist merely reveals himself in his art. The rise in individualism led the artist to recognize his true task (within the scope of bourgeois society, of course), and once he was aware of it, he focused on it further, bringing it to a logical end: easel painting became a means to extensively reveal personality. There was only one way to achieve this: greater expression exerts a greater influence on the viewer.

'What is the highest purpose of art if not effect?' asked Delacroix, the most typical and talented prophet of nineteenth-century painting.

However, this slogan was practically realized only after half a century. In the middle of the nineteenth century the artist had not yet severed his connection with nature, which offered him direct contact with a world, which he no longer had in the anarchically atomized human collective; on the contrary, he even intensified this bond for a time. The strangeness of this situation can be easily explained: the rapid growth of industrial cities caught the artist off guard, and he turned to nature with the helplessness of an unadjusted individualist. Transmitting nature in its full force and joyfulness became the purpose of the artist, but now this purpose was understood in a different way. The focus was not on the study of the material, as it was before, when artists anatomized dead bodies and walked in the streets, observing human faces. Now the artist with his new subjective approach to the world strove

thesis, 'The Aesthetic Relations of Art to Reality' (1853), which was one of the first philosophical aesthetic texts in Russian from a leftist perspective (eds).

to transmit nature in its sensory impact on us – he searched for sensations, not materials. This resulted in Impressionism, a subjective solution ('my sensation') to an objective task ('I wish to transmit reality as precisely as possible!').[11]

When the imperialist stage of development of bourgeois society brought it into a state of instability, when the ground under its feet oscillated, a significant part of the intelligentsia, namely, the regressive part, fell into extreme emotional subjectivism. The painters of this category now considered only their own experiences; the depicted object lost its realistic character and finally turned into a mere reason for independent painterly forms, devoid of any kind of specific material task. The easel painting became a means for maximal expression, nothing more. Starting with Van Gogh, the reactionary wing of painters receded into bare emotional formalism – Europe was soon filled with the so-called Expressionists.

Expressionism drew its conclusions from the preceding premises: from this point on every element in easel painting was valued insofar as it expressed the psychic state of the individual. It made no difference whether the painting depicted something or not and what exactly, how it was rendered, whether it corresponded with reality, the logic of facts, or some objective task. The only important thing was subjective consciousness: that the painting conveyed a certain complex of its creator's experiences.

This is how the implausible paradox, at first glance, was realized: initially confirmed as a means, easel painting became

11. The petty bourgeois consciousness could offer nothing else; the nature of its class is revealed in the political sphere as well: 'The Impressionist painter mostly avoided the rhetoric of socialism: he was apparently a democrat and only occasionally a socialist' (Theodor Däubler, *Im Kampf um die moderne Kunst*, 1919).

an end in itself. And since our epoch, while powerfully socializing the consciousness of some, at the same time brings the consciousness of others to a total solipsism, it is not surprising that Expressionism, the art of solipsism, concluded in our time with the work of the non-objective 'colourist' Vasili Kandinsky and the non-objective graphic artist Oskar Kokoschka.[12] Indeed, this solipsism is a confirmation of Van Gogh's suicide, insofar as there was nowhere else to go; in Kandinsky, easelism attained its highest and final achievement, pure form, reflecting the closed-to-the-real-world soul of the artist; closed-to-the-real-world, because where else should he (who had lost contact with the human collective) look for sources of inspiration, if not in the desolate non-objectivity of the otherworldly, metaphysical world.[13]

12. Wasn't it the English Impressionist James Whistler who called his paintings harmonies in pink and grey, nocturnes in black and gold, or arrangements in grey and black (the portraits of Thomas Carlyle and others) the indirect forerunner of Kandinsky? After all, Kandinsky, like Whistler, is a 'musician' in painting. Herein resides the aspiration towards colour abstraction. 'In painting one should strive for musical suggestion rather than literary description', declares Paul Gauguin. Kandinsky is much more specific: 'Painting has caught up with music, and both arts meet the growing tendency to create "absolute" compositions, i.e., limitlessly objective, growing like works of nature – "on their own" – in a purely natural way, like independent "beings".' The decadent painter continues with a naïve frankness, writing about his youth: 'Luckily, political life did not consume me completely. Other involvements allowed me to exercise the necessary ability to plunge into the delicate material milieu, which is called the sphere of the abstract' (Vasili Kandinsky, *Tekst khudozhnika*, 1918). Sure enough!

13. Analyzing Kandinsky's colour compositions Däubler notes with delight: 'The red of Pompeian frescoes in Kandinsky cannot be decorative in its base, as it appears to be absolute' (*op. cit.*). Neither Däubler, nor Kandinsky understood that this is precisely the social death of easel Expressionism.

But unfortunately for the artist and fortunately for humanity, metaphysics in its bare confirmation has never generated real results. Kandinsky and Kokoschka will probably have their epigones, but there will be nobody to continue them.[14]

Flight from the Easel

The creative work of the Expressionists, in essence, is merely the consistent and extreme expression of all bourgeois easel painting. The bourgeois artist, not having the opportunity and simply not being able to *paint walls*, occupies himself with '*painting*'; with the generosity of an upstart, he leaves the painting of walls to house painters.

One could object, though, that easel art has its specific organizing role in life, otherwise it would not exist at all. This is true, of course, but, as I have shown above, such art turns out to be necessary only in a disharmonious society; it is not the result of spiritual wealth, but of social evil. Moreover, I will try to prove now that even when theoretically justified, easel painting is factually stripped of viability.

And indeed.

14. They were saying that Kandinsky is searching for a solution in the synthesis of the arts – painting, sculpture, music and theatre. But whatever it may be, this union is possible only for currents related in their base. Kandinsky's synthesis, if it is successfully carried out, will be a synthesis of the arts outside of life, which life will inevitably separate again. The question is resolved on another plane. It is not the synthesis of the arts that gives them liveliness, but, on the contrary, their liveliness creates their synthesis. Let me simply note here that even such an extreme easelist as Kandinsky tries to find salvation beyond the easel, sharing in this peculiar form the fate of many (see more on this below).

Easel painting, as mentioned previously, is a separate, self-contained world that is valuable in itself: it is not in vain that it needs a frame! Its existence is isolated by necessity, but if this is its salvation, isn't it also its doom? After all, the isolation that the painting demands is absolutely unthinkable in our physical world. Besides, the conditions of capitalist society that created easelism put it in a situation that is alien to it. Unconsciously provoking the painter to create isolated works, the same society then deprives the artwork of its necessary isolation. Herein lies the main contradiction of bourgeois easelism. More concretely, it resides in the fact that permanent mass overproduction within a limited circle of private buyers leads bourgeois society to the creation of museums, bound to satisfy the needs of both the middle strata of the ruling class and young students of art. When history says A, then it always says B: evading life, art is hidden away in stone mausoleums to continue its existence as a shadow, visited by some accidental Odysseus. But this is where the most bitter disappointment awaits easel painting. Attached to a wall in an endless row of sisters in misfortune, it fatally loses what it had dreamt of so exaltedly: independence, self-containment! To its own horror, easel painting has to be what it so fervently denounced: a wall decoration, and – imagine that! – of a museum.

It is true, though, that, museum curators, sensing the somewhat inappropriate combination, usually select unique masterpieces of famous artists and exhibit them in separate 'chambers', where they rest on separate stretchers. But these are unique pieces; one might ask – what about the rest? The rest have to hang securely on the wall. And it is not surprising to see the indignation with which the thoroughly convinced contemporary easelist attacks the museums that are so disastrous for his painterly 'absolutes'. But ask him if he

knows the way out of the situation and, perplexed, he will grow silent, for the bourgeoisie, which has certainly not lost its mind, is not going to build a separate room for each one of his paintings! But this is exactly what our individualist is trying to get at![15] And is it not a characteristic of a degenerating art that, refusing to serve the processes of 'life-building', it finally had the great wish to turn 'life-building' subservient to itself?

Nevertheless, let us imagine a particularly serendipitous course of events: the painting ends up in a private residence, i.e., the very core of life. If the owner of this residence is a wealthy capitalist, he will arrange a 'gallery' for his paintings, in other words, the same museum. If he is a middle-class bourgeois, he will hang the work on the wall of one of his rooms. One might ask: on which wall, in which room? But it really makes 'no difference'. Is there anything that connects the seller to the buyer under the conditions of market exchange other than monetary relations? And someone's masterpiece ends up next to a tasteless lithograph, hanging (!) against the lurid wallpaper of a 'chic' guestroom – certainly not blending with it and not growing out of it organically.

Critics like to talk about the socio-ideological meaning of bourgeois painting with its class 'content'; as a counterbalance, they propose the creation of proletarian easel art – paintings that would formulate through their themes the consciousness of the working class.

But as I have already shown, easelism is a bourgeois form of artistic production, and this alone means that there can be no talk of proletarian easel art. Easel painting, whatever its theme, will always remain a product of bourgeois art, even if

15. My assertion is based on private conversations and arguments with a whole range of consistent easelists.

created by a proletarian; because it is created on an easel, and because it is a painting, its destiny is never to be proletarian.

Any prospect of easel painting having an ideological influence ends in fiasco, especially because of its form. Unsuitable for mass consumption, not tied to any *practical* social function, resistant to reproduction and accidental in its placement, it is organically incapable of a real effect that would justify the efforts put into its production. Delacroix, who painted *Liberty on the Barricades,* helped the movement of the French Revolution no more than Théodore Géricault, with his racehorses.

Easel painting could only have survived in a society where it was impossible to have organized creation within life, and which therefore had to be content with its surrogate form – depictive illusion. It is no accident that antique sculpture of 'beautiful' bodies blossomed alongside the decline of the Olympic games; and it is no accident that landscape painting triumphed in the city, by means of portraiture – in a society of alienated individualists, and so on.

It would have been very strange if we did not encounter any protest or instinctive struggle against this kind of situation. Any type of individualism, no matter how acutely it is expressed, has its limits; man, after all, is a social being even when he appears to be the son of an atomized collective. And if the bourgeois artist is always ready to call the consumers of his creation 'the rabble', is he not trying to achieve the most effectiveness, does he not wish to play the highest organizational role in life? It should suffice to remember the statements by Delacroix, Van Gogh and others, which I have quoted above, to understand how painful it must have been for these supreme masters to perceive their isolation and detachment from life when their paintings, destined to influence humanity, were

immured in museums or carefully concealed from the world in the secluded mansions of the wealthy bourgeoisie. It is not surprising, therefore, that the endless attempts to go beyond the boundaries of the easel towards the fresco have constantly accompanied the sustained progress of European painting, beginning with the age of machine capitalism (murals were frequent and common before this age).

It is characteristic that the technique of fresco painting had been forgotten by the nineteenth century, and artists had to relearn everything anew. But this did not stop the most discontented.

'It is hellishly difficult', wrote one of the German Nazarenes:[16]

To fill a whole room with paintings, done in a hitherto unfamiliar way. We prove to one another every day that we do not understand anything, and we criticize each other constantly. You cannot imagine how strange it is to see the wet plaster on the wall. And yet, we build castles in the air every day about how we will cover the churches, monasteries, and palaces of Germany with wall paintings.[17]

These were the dreams of painters from the period of the German princes. But if we were to look into other decades and ideas from the opposite pole, we would find a similar call by the art dictator of the Paris Commune, Gustave Courbet,

16. Arvatov probably means here the 'Nazarene movement', a group of early nineteenth-century German Romantic painters. The name Nazarene (also, the name of an early Christian sect) initially was a sarcastic nickname used against them for their fondness for biblical clothing and hairstyles (eds).

17. Richard Muther, *Geschichte der Malerei im 19. Jahrhundert*, Vol. I, Neufeld & Henius, Berlin, 1893.

who wrote about his contemporary painters: 'They should better decorate railway stations with sceneries where the road leads to, portraits of great men whose hometowns are along the way, depictions of factories, mines, machine galleries – these are the shrines and wonders of the nineteenth century.'[18]

The pull towards the fresco is especially symptomatic in the master who essentially was the father of modern easelism – Delacroix. His highest dreams were dreams about murals, monumental painting in some Pantheon. His most ambitious desires took shape in the murals for the Chamber of Deputies, the Church of Saint-Sulpice and the Salon de la Paix.[19]

And he is not the only one! Edward Burne-Jones, Pierre Puvis de Chavannes, Hans Makart, Arnold Böcklin, Maurice Denis, Henri Matisse and many others strove in their tragic search to go beyond the narrow frames of the studio easel whenever the Maecenases or states gave them the opportunity. Whenever they did not have such an opportunity, they sought the decorative in places where there could be no talk of decorativeness: in the same ill-fated field of easel painting. It was in vain that the friends of Paul Gauguin, who hopelessly dreamed of the art of life,[20] entreated society, pointing out the decorator it was neglecting; – 'society' remained deaf.

18. *Ibid.*, Vol. II.

19. See his *Diary* and letters.

20. 'How much more fragrant is the tea when it is poured into a self-made cup! How delightful are the small baskets made by each person for gathering cherries, and these wonderful vases for flowers that demand so much patience, agility and taste', wrote Gauguin with a sad helplessness about the Japanese peasants (Yakov Tugendhold, Zhisn' I tvorchest'vo Polja Gogena, [*The Life and Work of Paul Gauguin*], Moscow, 1918). It is worth noting here, how the individualist is unable to overcome the craftsman's mentality: he is talking about objects, but pay attention – they must necessarily be 'self-made' objects.

Who was right?

It is common to stigmatize the 'dull imperceptivity' of the bourgeoisie and to stand up in righteous indignation in defence of the rejected artist. This is rarely correct. The truth is that the bourgeois painter, who had basically unlearned building anything real, was unable to create viable decorative art. He either transferred easel techniques, with all the perspective effects and naturalistic illusionism, onto the fresco, thus destroying the wall, or, unable to create an original construction, he chose the path of stylization, i.e., imitating the ancient masters, before whom he bowed like a beggar bows before wealth. In his hands, decorative painting became a stronghold of reactionary aspirations, stopping the processes of independent artistic development. The escape from modernity, expressed in the church religiosity of the Nazarenes and Neoclassicists, or in the mysticism of the Pre-Raphaelites and Symbolists, was a deeply class-based phenomenon: both the form and the themes of this art, in the first case, served as a stronghold for the feudal (the Nazarenes) or oligarchic (the Neoclassicists) layers of society, and in the second case, allowed the intelligentsia discontented with life an exit into mysticism, who were supported in everything with regard to mysticism, by the sentimentally philanthropic bourgeoisie, always ready to dream of a distant past.[21] The same happened with graphic art, as it rejected Impressionism and tried to recover the long-lost feel of the surface – the page: the Englishman Aubrey Beardsley, the Frenchman Odilon Redon, and the German Max Klinger were all attracted to refined stylization, which appeared to them as a sign of

21. 'Most of them were Monarchists, Bonapartists, Catholics', writes Th. Däubler about the group of Maurice Denis (Theodor Däubler, Im Kampfe um die moderne Kunst. Erich Reiss, Berlin, 1919).

'exquisite taste', the weakness of which was evident in the creative work of their followers.

Closer to our time, the stronger is the amplitude of the stylized fantasies of bourgeois painting. From Raphael to Botticelli, from Botticelli to Giotto, from Giotto to Byzantine art, from Byzantine art to ancient Greek art, and from ancient Greek art to the art of savages – these were the consecutive steps of the vain race after the monumental style. As the organization of the senses of the personality became more refined, and as the deafening roar of modernity became more painfully felt, the more painting strove towards 'simplicity'. Its banner was primitivism; its slogan – a return to the past, no matter what. But if Raphael seemed simple at the beginning of the nineteenth century, by the beginning of the twentieth century even the savage seemed complex, and if the painter then protested only passively against the steam and engines that were so hateful to his craftsman's consciousness, now, having been finally persuaded by their victory, he escapes from society to some Tahiti, taking bourgeois society for the whole of humanity, capitalism for culture, and the temporary for the eternal. The egocentric soul was incapable of accepting the world as it was and effectively overcoming it; in the best case, the egocentric soul could choose defection, in the worst case – suicide. Occasionally, it could hope for help from another; but this hope is weak, utopian and therefore unable to save anyone. [22]

22. Van Gogh wrote: 'We live amidst total anarchy and dissolution . . . and torment ourselves to create style from a separate piece. If the Socialists erect their building, from which they are still very far away, it would be possible to have a rebirth of the previous order of life' (Yakov Tugendhold, *French Art and Its Representatives*, 1911). What is most interesting here is that socialism appears to Van Gogh as a 'previous order of life'. But life has its own logic, and Van Gogh ended his life by suicide.

Constructivism

As I have mentioned, the new movement in painting shifted from depictive painting to non-objective painting. This process evolved in two directions. One of them was Expressionism, which I have described above. It was an emotional play with forms, a path of extreme idealistic individualism.

The second direction in non-objective painting was Constructivism (Cézanne – Picasso – Tatlin) and it was directly opposed to Expressionism.

The radical, progressive part of the new intelligentsia, namely, the so-called technical intelligentsia, had been trained in the industrial centres of modernity and were imbued with the Positivism of the natural sciences – in other words, 'Americanized'. Its pathos became the pathos of the task, work, invention and technical conquests. While the old intelligentsia was soaring high above the clouds of 'pure' ideology, the new 'urbanized' intelligentsia made the world of things, material reality, the main object of its attention. These people wanted, first of all, to build and to construct.

Their representatives (mostly unconsciously) were the Constructivists.

The Constructivists declared the creative reworking of real materials as the main and even only purpose of art. They expanded the realm of artistic mastery by introducing into the easel composition a series of new materials besides paint considered 'unaesthetic' until then. Artists began to use stone, tin, glass, wood, wire and other materials to the utter bewilderment of the public, who did not understand the purpose and meaning of such works.

The painters finally discarded perspectival illusion as something not corresponding with the actual properties of the

material and moved away from two-dimensional paintings to three-dimensional constructions (Tatlin's counter-reliefs).

It should be said that easel painting has always been of material-technical importance. All paints, with the exception of the recently invented aniline-based paints, were first invented by artists and only then used in life, industry and the everyday. Easel painting, therefore, was an unconscious laboratory for experimenting with colouring substances. And Constructivism was tremendously important in the sense that it was the first consciously to start this kind of experimentation. No less important is the fact that as soon as the powerful chemical industry took over the improvement of paints, artists turned to the colour and form of other materials – materials which had been disregarded, because they were not artist's paints, but building materials.

What remained now was to make one final, but decisive step.

Indeed.

The main difference between the Constructivist and the actual organizer of objects, the engineer or worker, was that the Constructivist made non-utilitarian forms – all possible combinations of paper, textile, glass, and so on. Raised in the traditions of easelism, the new artist genuinely thought that this kind of art, which was not of immediate use to anyone, had its own self-sufficient meaning. The new artist spoke about the revolution of consciousness, the revolution of taste, and so on, imagining that he was creating independent worlds of forms and was, therefore, sinking in the swamp of 'do-it-yourselfism', while remaining tightly tied to the old easel.

There had to be the Proletarian October Revolution, there had to be the slogan, introduced by the working class: 'All for life!' for the Constructivists finally to open their eyes.

They understood that the real, creative reworking of materials would really become a great organizing force when it began creating necessary, utilitarian forms, i.e., objects.

3
Art and Production in the History of the Workers' Movement

Petty Bourgeois Utopianism

The workers' movement gained momentum only in the second quarter of the nineteenth century and was finally able to influence the artistic life of capitalist society. It was impossible for the proletariat to think about producing its own cadre of artists then; economic exploitation, on the one hand, and the low cultural level of workers, on the other, created a situation in which the proletariat aesthetically, in their tastes, were enslaved by bourgeois and petty bourgeois traditions. They assumed, therefore, that it was absolutely impossible to consciously influence the evolution of art at that time. There was some influence, but for the working class it was exerted unconsciously.

The sharp forms of class struggle that took an open and acutely perceptible character, the abject poverty and horrible conditions of manual labour began to attract the attention of intermediate social groups and, above all, the intelligentsia. This gave birth to utopian socialism, whose ideas united heterogeneous social elements. The problems of social harmony became unusually popular; dozens of brave experimenters attempted at once to realize their dreams in practice; they

thought that goodwill and conviction were enough for the realization of the socialist ideal.

Utopian socialism also attracted artists into its circle of ideas. The best-known artist among them was, of course, the Englishman William Morris.

Morris was a socialist-utopian. He struggled for the interests of the working class both politically and theoretically, but most of all he was preoccupied with the idea of socialist art. In a series of articles and in his books, Morris attacked capitalist society, where productive labour was not a joy, but torture. Morris's main idea was labour-creation, but to make labour into a creative act, he reasoned, meant to create objects that a person would want to own, i.e., fine objects, which meant fusing labour with art. Morris sharply criticized the clichéd, impracticable, pretentious forms of bourgeois everyday life; he spoke of its disharmony, of the need to construct a purposeful beauty – beauty within life, and not outside of it. But being a typical bourgeois artist, that is an artist-craftsman, Morris ascribed all the evils of capitalist relations to the machine. Morris harked back to the medieval system of guilds, which appeared to him as a social paradise. He organized art and craft workshops, but it was obvious that these workshops could not carry out large-scale production: craft could not compete with factory technique. So they had to switch to making rare objects – objects of luxury – i.e., reject essentially the very idea of fusing art with life. Moreover, despising advanced technique, Morris could not follow it, not even in the realm of external forms; instead, he copied medieval forms and the forms of the Renaissance, occupied himself with the superficial decoration of objects, making carpets and other things. After a while, his workshops declined into standard schools of applied art.

Morris's plan was petty bourgeois and reactionary-utopian: the machine won, and it could not have been otherwise.

Much later, when the proletariat created its massive class organizations, when these organizations acquired their own buildings, and when, consequently, the problems of the organization of proletarian everyday life emerged – the question of production-based art came to the fore again. The Belgian socialists Jules Destrée and Emile Vandervelde[1] took first place this time.

If previously, the problem was introduced externally, and remained unknown even to the working class, now it emerged from within the workers' organization. The party, workers' cooperatives and professional unions took control of it. But here, too, the proletariat turned out to be culturally weak; the real organizers became the theorists and artists from the intelligentsia who joined the ranks of the workers' movement and took an opportunistic position (it is not by chance that Vandervelde became one of the heads of the Second International). The problem was resolved again by following the well-trodden path of the bourgeoisie: bourgeois artists were invited to paint paintings on walls, concoct patterns and ornaments – in other words, the field was dominated by the same kind of inorganic, external embellishment. They were not even attempting to create new forms, make new objects, construct the 'material-everyday' of the proletariat in Belgium. They understood the 'proletarianization' of art to be its democratization, i.e., the wide circulation of bourgeois artistic works in the workplace. They sought aesthetic compromise just as they sought compromise in politics.

1. Jules Destrée (1863–1936) and Emile Vandervelde (1866–1938).

The exploitation of workers for bourgeois artistic purposes was widely practised by the capitalists themselves. In order to ensure the uninterrupted reproduction of capital in enterprises that produced objects aligned with the aesthetic taste of the market, it was necessary to maintain the same kind of uninterrupted reproduction of the workers' artistic force. The intelligentsia was capable only of welcoming solitary artists; they would come to the factory by chance and might leave at any moment. In the meantime, the capitalist class needed a stable cadre of applied artists who would be attached to production. Such a cadre, naturally, could be recruited only from the proletariat. The bourgeoisie established special industrial art schools where the most capable workers were sent for three or four years of education on scholarships paid by the owners of enterprises. After graduation they were required to work at another factory for a certain number of years.

It might seem that this path would produce an organic style: the artists were the quintessential class of producers. However, this is so only at first glance. The fact is that the organizational functions remained wholly in the hands of the bourgeoisie – the workers were its blind instruments, the mere executors. They were learning in the specialized schools the applied art techniques of the bourgeois artist, and were subordinated in the factory to the market interests of the capitalist.

This kind of employment of proletarian forces was widely practised in Germany during World War I and the German Revolution, when the besieged bourgeoisie had to beat their powerful competitors by producing goods of exquisite quality. The Deutscher Werkbund (German Association of Craftsmen) made the aesthetic quality of labour and the planned organization of German production its primary task. When the revolution took place and the problems of labour

came to the fore, the idea of production art was passionately upheld by the workers' parties (during the discussion at the Reichstag, the centre was passive, the right wing was opposed, while the chief defenders were the independents). The instigator, as before, was the bourgeois intelligentsia, revolutionized by the social catastrophe, and the solution to the question of production art again was reduced to the applied arts. Later, when the workers created their own artistic-production organization, the Werkbund invited them to join its ranks. But the workers refused, stating the following: the Werkbund makes expensive, rare objects – the proletariat has nothing in common with it. Instead, the workers' organization took over the production of simple, inexpensive furniture, which could serve the everyday needs of the proletariat. But as Stinnes's Germany does not allow the working class to use advanced factory techniques for its own purposes, the attempt of the German workers is doomed to stagnation.

Art and the October Revolution

By the time of the October Revolution, art was at a dead end. The right ('depicters') were helplessly marking time, playing a tragicomic melodrama in disguise, the costumes of which were copied from Egypt, or Greece, or the buried Versailles (Mstislav Dobuzhinsky, Alexandre Benois, Ivan Zholtovsky, etc.).[2] The left were rabidly destroying everything, including themselves, but the only great and valuable thing that they carried with them was the passionate desire to break through

2. Mstislav Dobuzhinsky (1875–1975) was a Russian painter of bleak cityscapes and a theatre scenographer; Alexandre Benois (1870–1960) was a Russian painter of romantic, historical scenes and a stage and costume designer for Diaghilev's *Ballet Russes* (eds).

the present, the revolutionary courage of inquisitive youth who hated cliché, fetish and copy.

A great deal has been written about the pre-eminence of Futurism during the first years of the October Revolution. These writers tried to give various explanations, saying that Soviet rule had to agree to a 'left' mésalliance as it had no one else by its side – only the left had accepted the October Revolution. They were talking about an emotional analogy between the left in art and the left in politics. They were saying other things, too, trying to accuse young artists of a lack of impartiality.

The matter, it seems to me, was much more complex.

First of all, let me establish one historical fact: both the right and the left came to negotiate with the Soviet government. They both brought with them projects and plans; and they both agreed to collaborate with the proletarian revolution.

Why, then, was precedence given to the left?

If we examine the plans proposed by the right (headed by Benois), they all came to one thing – the preservation of art and antiquities.[3] These museum people saw nothing in the revolution but a destructive hurricane that threatened to raze to the ground the remains of the past so dear to their hearts. Having dug themselves into the sands of centuries, they did not want to know anything about today or tomorrow. The right did not think about schools, about live art-making – they were concerned only with mummies – but this was not the revolution's concern. The revolution demanded something else. The academy, specialist schools, committees were filled with politically reactionary professors. Under the guise of Realism they concealed their Black-Hundredist desires,

3. Benois became curator of the Old Masters Gallery at the Hermitage, Leningrad, between 1918 and 1926 (eds).

while the cadet-priests of 'eternal art' hissed malevolently from everywhere.[4] They had to be decimated, cleared away, neutralized – this was not an aesthetic demand, but a purely politic one. The right were not well suited for such 'sacrilege'.

But the left were.

Revolting against the past for the sake of the future, the left fought on the artistic front line against the same society that the revolution had opposed economically and politically, headed by the proletariat. The left was bound up with the same preoccupations as the revolution: the destinies of today's art-making. Instead of worrying about the rubble of some Old-Testamentish cathedral, the left took over the task of reorganizing the educational institutions of the republic. Cast away in the back-alleys and hiding out in dismal attics, they saw in the revolution the freedom of opportunity, equal rights and the possibility to campaign not only in words, but also deeds for the principles that were declared by the new art. If, from the perspective of the revolution, the academy was a stronghold of political reaction, for the left it was a citadel of artistic reaction. Thus, the interests of both sides coincided. But apart from that: the struggle for the new art was not merely a struggle of the underprivileged against the privileged, it was also the struggle of students and young people who were discontented with the old forms, with the traditions and the scholastic models of the professoriate. The reform of the

4. *Chernosotentsy* or the Black Hundreds was an ultra-nationalist, antirevolutionary, and xenophobic movement in Russia that grew in reaction to the Russian Revolution of 1905. (trans.) Cadets or 'kadets' is an abbreviation for members of the Constitutional Democratic Party, encompassing constitutional monarchists and republicans; this party was the main liberal political force in Russia before the October Revolution (eds).

academy, carried out by the left (Nathan Altman, Nikolay Punin, Osip Brik, David Shterenberg, Alexei Karev, and others),[5] was met by the students with great enthusiasm; their conference, which took place in 1918, greeted the October Revolution as its own victory, and it was, of course, right.

And so, the left won. New artists began to teach along with the old artists in school; museums began to show the works of Tatlin, Malevich, Kandinsky, and many exhibitions showed the works of young masters.

The right surrendered their positions without a fight. One of their factions, for the lack of creative material, began to restore ancient Rus, another receded into an almost underground existence, some, taking heart, went to work as specialists, while the rest either stopped working altogether or emigrated to Europe to surprise the Europeans with home-grown Russian Cézannes and patriotic cliches à la Russe. Under the wings of Parisian and Berlin generals, these gentlemen lay in wait for the collapse of the revolution, disparaging the cause that was emerging from Soviet Russia.

* * *

The left helped the revolution. But their help was mostly 'negative': they were much-needed and sole collaborators, as long as it was necessary to fight against the counter-revolution and carry out destructive tasks.

5. Nathan Altman (1889–1970) was a Russian cubist painter and stage designer; Nikolay Punin (1888–1953) was a writer and administrator, in 1918 he was appointed head of the Petrograd Committee for Education (Narkompros); Osip Brik (1888–1945) was a Russian Futurist literary critic and theorist; David Shterenberg (1881–1948), was a Russian, Cubist-influenced painter; Alexei Karev (1879–1942) was a Russian painter influenced by post-impressionism (eds).

Everything changed completely as soon as the tasks of destruction had to be replaced by positive, organizational tasks. Opening up all the possibilities for the new art, and immediately after the intensity of the first months, the revolution made powerful demands upon its fellow travellers. The political workers of the October Revolution were saying: 'We gave you, artists, what you wanted. Now you must give us what we want: posters, illustrations, drawings – give us works that are useful, comprehensible today – now – as we cannot wait.' And when left-wing artists responded that their task was the revolution and people's consciousness, that the level of the masses had to be raised, that they could not appeal to a cultureless Russia – they rightly received objections: 'The revolution cannot wait for the nation to regenerate itself. The revolution needs helpers today – especially when nobody knows how much better your, leftist, incomprehensible forms are compared to the old forms that were familiar and recognizable.'

The concept of people's art had become hugely popular since February 1917. The right understood this popularity in relation to the depictive dimension of art (recognizable pictures), whereas the left (non-objective art) naturally pushed the decorative issue to the fore. But here, too, they were unable to offer anything substantial. Given the scarcity of material resources, the decorative projects of the left pursued, first of all, a struggle against traditional forms of everyday life. In other words, their decorations were meant as pure protest and that alone did not satisfy the needs of the traditional conscious-ness of their contemporaries. And no matter how ingenious Nathan Altman's work appeared to be (the decoration of

Uritsky Square in Petrograd in 1918),[6] it underscored once more the 'aesthetic' dissonance between the political left and the left in art.

As political pressure increased, the inability of the left to adapt became even more apparent. Refusing to paint depictive objects, leftist painters who came from the ranks of the old art, and had been trained on the autotelic easel, saw in the revolutionary pressure a threat to their art. Fighting against the fetishism of the past, they, the convinced easelists, the heroes of the same 'pure art', (only now in a new form), fetishized their own creation no less than the old masters once did. This is what caused their defeat in the revolution.

The period of 'Sturm und Drang' had to subside in order for the governing circles to collect themselves, look around, and declare a campaign against 'Futurism'. They began to make reassignments in the administrative centres, there were changes in the educational institutions, they began to commission the so-called 'Realists' – the right were temporarily triumphant. But already the first results of their activity disappointed even the most convinced conservators of art among the revolutionary politicians.

The revolution brought about the rival camps' downfall: both the 'depicters' and the non-objectivists capitulated in the face of the revolutionary demand to fuse the tasks of artistic creation with the tasks of 'social building'. In other words, the defeated party, independent of different artistic directions, was 'pure art', or more specifically, easelism.

* * *

6. This was an extensive abstract design covering the neo-classical buildings in Uritsky Square, in commemoration of the first anniversary of the Revolution (eds).

At about the same time, a new group was beginning to form inside the left called the Productionists. Accepting the revolution ideologically and not spontaneously, because the revolution was beneficial for them, these people searched doggedly for a link between art and social practice; having the worldview of revolutionary Marxism, they inevitably came to the inescapable conclusion that they had to break their ties with any kind of 'pure art', including that of the left. Starting with the criticism of the main concepts of bourgeois aesthetics, they raised the question of the methods of artistic labour, instead of the question of form. The idea of proletarian art prompted a solution: the collectivization of artistic labour was senseless without a synthesis with the sphere of social practice, which was the basis of contemporary collective building, namely – industry.

The question of Production Art was born, therefore, as a natural result of the Proletarian Revolution, but it also became a stumbling block not only for the art of the right, but also of the left.

And indeed.

The conversation was no longer about a change in artistic forms, or the struggle of movements in bourgeois art, or the use of forms for the decoration of objects (applied art) – it was about total liquidation, a complete break from all the devices of contemporary artistic creation. It was a campaign against any type of individual craft method coming from the right or the left.

The situation changed abruptly, and with that change came a change in the course of struggle between artistic groups. This led to a schism among the left. The majority of those artists who had held tight to the easel and were fearful of seeing themselves entangled in a revolution – which they had only

recently blessed – immediately began to backtrack. A psychological reaction eventually led to the touching unification of the right and the left (the movement called 'World of Art')[7] on the grounds of self-defence against the bogeyman of Productionism. The easel turned out to be more precious than the profoundest disagreements over that same easel.

The first ones to retreat were the Expressionists, headed by Kandinsky – their mystical-emotional soul could not withstand the pressure coming from the radicals. Then the Suprematists rebelled under the leadership of Malevich; being convinced autotelics, they kept shouting about the murder of 'consecrated' art; their consciousness being unreceptive to anything other than the conventional easel form. The split was inevitable. In 1920 the INKhUK (Institute of Artistic Culture) that once united the left fell apart; after some time it resumed its work under the flag of Production Art. After a long process of reflection and after persistent struggle, a group of Constructivists (Tatlin, Rodchenko, the OBMOKhU (Society of Young Artists)) crystallized inside the left, basing their praxis on the study and processing of real materials as a transitional stage to construction engineering. During a famous session at the INKhUK, it was unanimously decided to abandon autotelic construction and undertake all necessary measures to connect with industrial production immediately.

Productionist Art and LEF

The Production Art movement was the result of three revolutionary processes, historically connected to one another.

7. The World of Art was a Russian late nineteenth and early twentieth century movement of Symbolist artists and writers supported by Sergei Diaghilev (eds).

The first one is the technical revolution discussed in the first chapter, which brought about a subversion in the forms of 'material-everyday' and which thus created grounds for the further, already conscious-intentional building of a new organic style. The second is the revolution inside art, which resulted in artists moving from image to construction and, consequently, delivered a cadre of organizers of style. And finally, the third is the social revolution that raised the problem of an holistic organization of life where every branch of activity would be closely connected with all the rest on the basis of collective labour (i.e., industrial) practice. The result of these three revolutions, which somehow coincided with one another in time and, to some considerable degree, in space, was the formation of a group of theorists and artists in the Soviet Union called LEF (Left Front of the Arts) that scientifically and practically worked out the problem of Production Art.

LEF consisted, on the one hand, of former Futurists and Constructivists and, on the other, of workers from the left wing of the proletarian artistic movement, and, partially, communist theorists.

The essence of what I will provisionally call the LEFist programme is as follows.

As the tendency of our epoch is that of industrial collectivism, society is given the opportunity to use its powerful and all-encompassing technique to consciously build its own life and, consequently, establish the concrete forms in which this life can be realized. Artists must abandon the aesthetic of contemplation and admiration, they must abandon the indi-vidualistically inspired dreams about life, which they had used to create illusory beauty in paintings and statues, depicting life or decorating it externally, and instead they must build life and its material forms. Art must become utilitarian from

beginning to end, according to the LEFists; pure art, art for art's sake, form as an end in itself – these are the products of the disorganized bourgeois social order, which evolved spontaneously and, thus, could not manage the concrete material of development and introduce inventiveness into life.

The practical programme of LEF is the organic connection of art with the production of material values, with industry. The word 'organic' needs to be emphasized here. It has been pointed out before that the question of fusing art with production was raised and resolved on numerous occasions, that converting artistic energy into the making of objects was the purpose of many artistic groups, however the LEFist movement is radically different from all other beginnings: it differs fundamentally in the methods that Russian Productionists consider necessary for the employment of art in production, as well as – and this is especially important – in the understanding of the nature of artistic creation and its meaning in the building of material culture.

First of all, the LEFists categorically reject all artisanal-craft arts as technically reactionary; second, they fight with no less determination against applied or decorative art, which, from their point of view, is perceived to be 'pure art', like easel art, because it strives to apply a decorative form from outside, to the object endowing it with proverbial 'beauty'. Finally, the LEFists are against all kinds of stylization, copies after the fetishized forms of the past; the LEFists are for contemporary, urban, industrial, 'Americanized' art – to the minutest detail. They do not wish to create rarities or objects of luxury, or so-called 'artistic artefacts' as a counterbalance to objects of everyday life; the purpose of the LEFists is to turn all art into the construction of material culture in close contact with engineering.

It is obvious that for such a purpose the old solitary artists, who came to the factory with their craftsmanship, were useless, and LEF proposed a grandiose programme for the reform of art education, the transformation of our current schools of painting and decorative arts into polytechnic institutes that would train engineers and constructors, armed with the whole apparatus of technical knowledge, methods of scientific organization of labour and production-based attitude to form.

Socio-technical purposefulness is the only governing law, the only criterion of artistic, i.e., form-inventing, activity. The more the object possesses this quality, the LEFists insist, the more artistic it is. But the socio-technical qualities of the object is nothing other than its production qualities, that is, the qualities of the methods of production. Therefore, the entrance of art into production for the LEFists is not a means of saving art or aestheticizing objects, but a means of improving production itself. The object that has the highest quality, the most flexible and effective construction, the best form for realizing its purpose, is the most perfect work of art.

We have such objects only when their function compels the engineers to a certain form that does not allow for any deviations, i.e., among the various kinds of machine apparatuses. Something very different can be observed in everyday life; here, every object allows for thousands of variants, and since technical engineering does not have specific formal tasks in this case, our everyday life is filled with archaisms, decorative flotsam and jetsam, obsolete models, millions of accidental, disconnected forms – it represents an egregious rejection of any purposefulness. One should also not forget that contemporary engineering, even technically the most revolutionary kind, is entirely conservative from the aesthetic point of view and for their most part culturally illiterate –

and so, a striking contradiction is formed between the form of objects and their purpose and technical progress.

In the overwhelming majority of cases the engineer is simply not capable of understanding that his machine is incomparably more perfect in its form than those little patterns, swirls and other such applied and non-applied charms from the baggage of 'pure art', to which the engineer bows down as before creations of some unfathomable inspiration. It should never be presumed that engineers are against contact with art; on the contrary, they welcome it in every possible way. But if you make the effort to find out how they might realize this contact, you will encounter the same applied aestheticism. In a series of conversations with engineers, I have tried to explain why it is necessary to teach the artist engineering, to cultivate the techniques of his creation within production and in the exclusive interests of production itself. I have always received the same response: 'It would be much better if the artists could teach us engineers art in our institutions of higher education. The artist is a creator – why would he need technique!' I had to explain at length why artists, in their current state, are only capable of teaching engineers an individualist easel aesthetic, which has no relation to production, that artists can draw lilies, but cannot build objects, that even in polytechnic institutes, they teach copying from Greek and Egyptian architectural styles, and that this is why it is necessary and inevitable first to have a Productionist revolution within the field of art – artists must be trained or re-educated in engineering.

The Productionist artist must become an engineer-constructor, replacing the present-day construction engineers in the enterprises. Only then will art walk hand in hand with technology and science, revealing itself as an equal, organizationally powerful and progressive builder of society,

transferring its creative abilities from the sphere of illusion into the sphere of a real change of life.

It goes without saying that the LEFists connect the realization of such a fusion of art and production with the successes of social collectivization. The LEFists understand that the creative construction of objects can be achieved only when people plan and consciously manage the entire production, while formulating the material conditions of their existence in the same planned and conscious manner. Productionist art will gradually become a fact of life with the gradual development of collectivization. Its ultimate victory is closely connected with the advent of the socialist order. And just as people are not waiting for socialism and are amassing its elements right now – so Productionist art must be realized now as far as possible.

4
Art in the System
of Proletarian Culture

Methodology

The question of proletarian art is a question of a particular system of art, subordinated to the general system of proletarian culture. And the question of proletarian artistic *practice* is a question of how such a practice, in all of its elements, would coincide organically with the methods of 'social building' applied by the proletariat.

If we analyze the various aspects of artistic creation, we will see that there are four problems in the practice of art: 1) artistic technique, 2) collaboration in art, 3) ideology of artists, 4) art and everyday life.

We will have to examine all of these spheres in the subsequent pages. The more specific question of so-called 'depictiveness' in art will be discussed separately.

Technique

At a time when the entire capitalist society is being built on the highest, latest advancements of its technical achievements – the techniques of mass production (industry, radio, transportation, newspapers, scientific laboratories, etc.) – bourgeois art continues to remain principally craft-oriented

and is forced, because of this, to isolate itself from the social practice of humanity in the realm of pure aesthetics. Even in the so-called artistic industry, where the bourgeois artist is supposed to come into contact with material production, he continues to hold onto his craft skills: taking an already produced object, he decorates it using the method of 'sketching', and brings the aesthetic devices of the studio into the factory. The painter, the poet, the musician and others are all craftsmen: bourgeois society cannot imagine any other kind of art. Bourgeois society believes that the engagement with art, and artistic creation, means creating craft products, using craft instruments and devices. The solitary master is the only type of artist in capitalist society – the specialist in 'pure art', who works outside the immediately utilitarian practice, as the latter is based on machine technique. This is the origin of the illusion that art is an end in itself; from here originate its bourgeois fetishes.

The first task of the working class in art is the eradication of the historically relative boundary between artistic technique and general social technique.

In order to accomplish this, before anything else, it is necessary to change radically the classification of the arts and their place in the cultural whole. Bourgeois aesthetics unified all types of art into a single group, differentiating them based on purely formal features. Poetry appeared in the same category as music, theatre, painting (i.e., easel art), then there were the so-called applied arts ('embellishment', fashion); all of these together were juxtaposed against the rest of human activity, as the artistic against the non-artistic. Meanwhile, when objectively analyzing the different types of art, it turns out that each one of them has something in common with the corresponding types of utilitarian practice. It is this

commonality, namely the organizable *material* in a given art that should become the basis of artistic classification.

The painter is someone who knows how to master paints, the poet – how to master speech, the film director – how to master human actions, and so on. Only this kind of approach can help find a bridge between art and life in the broad sense of the word. Then it would be necessary to view the art of painting as a special branch of paint production, the art of speech – a branch of literary production, and so on. From this angle, theatre would appear as a stage form of organization of human action, chamber music – a 'spectacular' form of organization of acoustic material, and so on. Consequently, any utilitarian production includes in itself a special realm of artistic labour; this was never directly acknowledged or applied until now. Poetry and journalism, theatre and street performance, painting a wall and painting a painting – these were considered not only unrelated; but even opposed to one another ('I am not a publicist', the bourgeois prose writer would say arrogantly; 'I am not a wall painter', the bourgeois painter would declare with the same arrogance).

Proletarian monism[1] must break away from this kind of opposition; on the contrary, art must be seen as the highest type, as the maximally qualified organization in every given sphere of its application, in every given realm of general 'social building' (as we recall, the word 'art' is derived from the word 'skill').

1. Proletarian monism was coined by the philosopher and a founding member of the Bolshevik Party, Alexander Bogdanov, and refers to the notion that collective labour is the origin of all 'elements of experience' which human subjects possess and organize, and is opposed to 'bourgeois dualism' (eds).

Bourgeois art 'knew' a narrow series of devices and forms (painting, verse, sonata, play, statue, palace, etc.); all other technical devices and material forms were considered to be either 'low' and 'peripheral' (parties, feuilletons, posters, etc.) or non-aesthetic (newspaper articles, sport, objects, etc.). The tasks of artistic creation were divided in a similar fashion: there were 'high', 'spiritual' and 'low' (utilitarian) tasks. The bourgeoisie recognized only a few forms of creation as 'real', 'authentic' art – namely, those that were not directly connected with social practice, that stood above life 'untarnished', as it were, by its 'dirty' toil (see, for example, Pushkin's poems 'The Poet' and 'The Rabble'). The working class must put an end to such aesthetic gourmandism, investing artistic labour in all kinds of toil, and use purposeful techniques to organize the necessary forms that society needs.

The fetishism of aesthetic devices, forms and tasks must be eradicated.

And this concerns first of all art's materials. Bourgeois artists had an exclusively specialized, traditional selection of materials considered to be 'worthy' of art. Painters worked with oil paints and watercolours, ignoring the enormous, unencompassable richness that the colour surfaces of the bodies of nature have to offer. Sculptors preferred bronze and marble, while the artistic trades favoured crystal, silk, velvet and other luxury materials. Only these materials appeared to be 'beautiful' and aesthetic to the traditional bourgeois consciousness. And poetry was ruled by a special set of 'poetic' words and expressions (such as 'stallion', 'bliss', 'rapture', 'languid', etc.).

The proletarian artist must aspire to organize any kind of material creatively, be it noise in music, street words in poetry, iron or aluminium in art, or circus stunts in theatre.

The fetishism of aesthetic materials must be eradicated.

All of this will be possible only if artistic technique breaks away from its current backwardness, if it rises to the level of the technique of material production, and if the proletariat eliminates the insularity of the aesthetic instruments of labour. Individualism in bourgeois society does not allow for even the consideration of machine technique or scientific-laboratory technique in art. It would violate the 'freedom' of creation, according to bourgeois aesthetics. Meanwhile, the question of instruments is a social question: the brush, the violin, etc., are the monopolized and fetishized instruments of creation only in an individualistic society. This restriction does not apply to the proletariat, the class of conscious-collective producers. In its hands the machine, the printing press in polygraphy and textile printing, electricity, radio, motor trans-portation, lighting technology, etc., can become versatile but incomparably more powerful instruments of artistic labour. Thus, the revolutionary task of proletarian art is the mastery of all kinds of advanced technique with its instruments, with its division of labour, with its tendency to collectivize, and with its methods of planning. A unique 'electrification' of art, engineerism in artistic labour – this is the formal purpose of contemporary proletarian practice.

The fetishism of aesthetic instruments must be eradicated.

Only such technical tendencies can turn art into the creation of real life, and allow the artist to become a real and equal collaborator in the task of 'social building'. Drawing on a technique common to the other realms of life, the artist is governed by the idea of purposefulness, processing materials not for the interest of subjective tastes, but according to the objective tasks of production.

Bourgeois art was, of course, not devoid of the idea of purposefulness, but there purposefulness was employed on purely aesthetic grounds – a work of art had to be purposeful only for auditory or visual contemplation. The focus was on the so-called purposeful harmony of forms, on compositional purposefulness; the product of art had to 'please', i.e., it had to satisfy the subjective, fetishistic, formally cultivated taste. The purposeful meant 'beautiful', and 'beautiful' meant anything that impressed the consumer.

Proletarian art must be built on the principle of the objective – in this case, corresponding with class – and universal purposefulness, which includes technical, social and ideological purposefulness, and which subordinates to itself the processing of materials (constructiveness, economy, consideration of properties) as well as the organization of forms (liquidation of external decorations, old stylizations, illusoriness, traditional clichés), up-to-dateness and adjustment to everyday life.

The question of proletarian artistic technique is the question of socio-technical monism in art.

Collaboration in Art

So far, Marxist thought has not attempted to approach art, the system of artistic creation, as a special realm of socially necessary labour. Unfortunately, the principled differentiation between 'labour' and 'creation', understood as something purposeful from the bourgeois perspective, continues to dominate Marxist theory and criticism. In reality, such a differentiation exists only to the extent that it is called forth by the class division of a society, where the initiatory-organizational functions are assumed by the bourgeoisie, and its agent the intelligentsia (so called 'creation'), while the implementa-

tional and partly organizational functions are placed on the shoulders of the exploited classes (so called 'labour').

Proletarian science cannot operate with such a historically relative and fetishized differentiation. From the proletarian, i.e., monist, perspective, any realm of public activity is a form of social-labour activity and must be regarded as such.

Only when we analyse the activity of artists socially and economically – and not psychologically, philosophically or formally – will its true nature, its real, objectively demonstrable properties in a given historical period be clear to us.

If we look at bourgeois art from this perspective, it will become obvious that it is wholly subordinated to the entire structure of capitalism. Just as the capitalist economy is an exchange economy, and capitalist production is private production for the market – so too the bourgeois art 'economy' is an exchange economy and bourgeois artistic production is production for the market, i.e., commodity artistic production on the basis of craft technique. In the late Middle Ages, artists worked exclusively on commission, knew their customers and were governed by his special needs; with the victory of exchange relations, the artist became gradually disconnected from the customer, from his own guild, and in developed capitalist society he has completely and finally turned into an independent commodity producer working for the market – an impersonal, blind, unfamiliar market. So-called easelism is that very materialized commodity, bourgeois artistic production in the form of a product. Any easelist work (painting, piano concerts, etc.) is a commodity-form of art. The artist, who is also a commodity producer, has to make products that would intrinsically have their own exchange value and could circulate in the market, while remaining at the same time the products of individual, craft labour. It is obvious that neither the objects

of material everyday life nor the various applications of artistic labour to the objects of material everyday life (decoration, for example) could be such products, since material everyday life in capitalist society is built on mechanized mass production. This is why easel art emerged in bourgeois society and became its central and commanding realm of creative work. The evolution of artistic forms under capitalism took place only in easel art: architecture was repeating the earlier styles; applied art was doing the same, while fresco painting degenerated.

The economy of bourgeois art did not only individualize the forms of artistic production, but also put them outside of the social process of production, treated them as specialisms, and turned them into pure aesthetic forms. Artistic labour existed as 'decoration', 'luxury' or 'entertainment', and its products were used in the hours of leisure, when one would leave the sphere of 'social building'. Through art one was supposed to forget reality, experience 'pure' enjoyment, attain the highest spiritual pleasure; art provided the 'beauty' that life lacked.

The proletariat will inevitably arrive at the socialization of artistic labour, the eradication of private ownership of not only products (this is only an immediate result), but also of the instruments and means of artistic production. The tendencies of proletarian artistic production, already evident in our day, will be a natural form of artistic production – working directly for the collective consumer and subordinated, in whole or in part, to the entire system of social production.

This means, first of all, that proletarian artistic collectives must enter into and collaborate with the collectives and unions of various branches of production, the materials of which will be shaped by the corresponding forms of art. So, for instance, agitation-theatre joins the state agitation apparatus as an organ of education; the theatre of mass and other

everyday life activities is linked to the institutes of physical culture, communal organizations, etc.; poets join journal and newspaper unions and through them connect with linguistic societies; industrial artists work by assignment in the organizational system of industrial centres, and so on.

Within such a structure of artistic labour, individual artists become the collaborators of engineers, scientists, and administrators, organizing a common product, while being guided not by personal impulses, but the objective needs of social production, and carrying out the assignments of the class through its organizational centres.

Art, as a direct and consciously, methodically employed instrument of 'life-building' – this is the formula for the existence of proletarian art.

Ideology of Artists

The economy of bourgeois art determined both the methods and ideology of creative work in capitalist society.

The solitary artist, who worked for the undefined market, could control only his personal skills in his creative work; in his imagination, art was a means of expressing the creative impulses of an independent personality; 'freely' chosen devices, a personally transmittable tradition, individual inventiveness – these were the sources of his activity. The artist proceeded from himself and only himself. He created objects as he wished, prompted by his subjective taste, his 'intuition', 'inspiration'. He was the master, but he did not know and did not understand the nature, social and technical laws of his mastery, and evaluated his creative work as something either above or below consciousness, as a purely emotional, spontaneous phenomenon.

In other words, the artistic ideology of bourgeois society became the justification of its artistic practice, turning transient artistic forms into the constant and 'eternal' property of every art. So, for example, up till now, bourgeois art history is, with a few minor exceptions, the history of artists (heroes, generals of aesthetics) and not the history of artistic devices (artistic production). Up to this day, art, as something irrational, is positioned in opposition to science, as that which kills, that is 'dry' and rational.

Since every art has a technique, bourgeois art could not do without a certain methodology, without the elementary scientific application of technical devices. It developed a series of 'domestic' disciplines, aesthetic pseudo-sciences, which were literally just ancillary theories, examining the object not scientifically, but from the point of view of a given artistic direction (for example, Impressionist colour theory; the teaching of perspective; musical scales, etc.). The artist was not subordinate to the demands of exact knowledge, but rather science subserviently justified the narrowly specialized practice of the artist. The artist employed not the achievements of social experience, but his personal, professional, relative experience, which nonetheless was elevated to the only 'true' criterion – the absolute. Society and nature in these theories were examined and evaluated from the viewpoint of art. Instead of socializing aesthetics, scientists aestheticized the social milieu.

The spontaneity of bourgeois art is clearly impossible within the system of proletarian culture – a conscious and planned culture. Just as the working class, in its politico-economic activities and in its production programme, subordinates practice to exact scientific formulation (Marxism, scientific organization of labour, etc.), the artistic practice of the proletariat must be built in the same way. The normalization

of the processes of artistic creation, their rationalization and the conscious determination of both tasks and methods of 'art-building' – this is the artistic politics of the proletariat.

The scientific organization of artistic labour and production is naturally divided into two spheres: artistic education and artistic production.

Contemporary artistic educational institutions produce semi-literate specialists, who, for example, do not study perspective from the point of view of analytical and descriptive geometry, i.e., from an elementary-scientific point of view, but rather from the viewer's point of view; or they do not study gesture from the point of view of the teaching on reflex, but from the perspective of stage performance; and so on. In painting schools they study colour not with textbooks of physics but books on aesthetics ('combination of white and black', 'harmony' of colours, etc.); in poetry classes they study the 'laws' of rhythm and other formal elements of poetry with almost no connection to real linguistic material ('right' or 'wrong' rhythm, etc.); in music schools they study everything but the production of instruments, i.e., the most basic thing in music production.

I could present many more examples.

The most telling, perhaps, is the education programme for architects. The focal point of this programme in the contemporary academies of the arts is the history of styles, while technique is viewed as something ancillary, as a means of constructing a predetermined form based on the study of 'styles'. Architects are taught to decorate, rather than build.

The working class must transform these educational establishments into polytechnic institutes where art would be studied based on scientific methods, the laboratories of which would be constructed on the basis of a common technology of

materials, while the methods of work would be subordinated to the technical demands of modernity.

The chemical technologist is no less important for the art of painting, than its constructor – the painter; the building engineer must replace the architect-stylizer; the musician must become in the first place an inventor not of sound combinations but of sound machines; the film director must collaborate with the instructor of physical culture and the psycho-technician, while the poet must collaborate with the linguist.

Such a revolution of methods will not only create a new type of artist, but also a new type of artistic education for all non-artists.

The bourgeois system of education was in all its branches partial, specialized. The young generation was raised in a one-sided way, incapable of either a balanced and plastic resistance to the reactions of the milieu, or an independent choice of profession. The artist was either discovered through tortuous trials, or the path was predetermined for the younger generation (family tradition, family environment).

The initial task of proletarian education is to prepare such human material, which would, first of all, be capable of evolving further in the desired direction, while simultaneously resisting the hostile 'reactions of the milieu', and, second, be maximally socialized. All of these issues are resolved through the monistic and class-based education of people. But such an education is impossible if it does not include, as an essential component, the artistic formulation of activities for children and youth, as art is the type of creation that extends the possibilities of an individual in a collective in the fullest, most harmonious way.

Bourgeois methods of artistic creation are so individualistic, so cut off from the social practices and everyday needs that they cannot be useful for the education of a socially active person. Built on contemplative formalism, on aestheticism, these methods are incapable of organically entering the general system of education. When in bourgeois society children are taught different arts, it is presented as an additional, 'enjoyable', 'higher' and 'extra-curricular' privilege, disconnected from the future socio-utilitarian activity of the person. The child is taught to sing because 'it is pleasant to know how to sing', or because 'he has a voice', or because 'there is beauty in singing'. Usually, everything comes down to tradition: 'it is a custom'. The bourgeoisie does not even suspect that the human voice needs to be generally organized for any kind of function (conversation, speech, report, etc.), that such an organization is unattainable without artistic formulation.

And indeed.

Artists organize everything that people organize at every step of their activity. Colour, sound, word, etc., constitute (in their spatial and temporal forms) the object of every person's activity. Every person must know how to walk, how to talk, how to arrange around him the world of things with their qualitative properties, and so on. But the preparation for such form-organizing practices in bourgeois society is the monopoly of the caste of art specialists. Other mortals are deprived of such means of artistic organization. Moreover, complete disharmony is the distinctive feature of the members of bourgeois society.

The task of the proletariat is to destroy this boundary between artists, as monopolists of some kind of 'beauty', and society as a whole – to make the methods of art education the

methods of general education aimed at the cultivation of a socially harmonized personality.

The current bourgeois methods of artistic creation are completely useless for the solution of the proposed task. So, for example, Dalcroze eurhythmics,[2] which is essentially necessary not just for dancers and actors but everyone, rests not on the study of a person's real, material rhythms in their concrete variability, but on the aestheticized, ossified fundament of abstract musical forms. Even contemporary biomechanics would rather formulate stage performance, than organize a person's real, effective orientation in a material environment. The bourgeois actor knows how 'to show' movement aesthetically on stage, but he moves just as helplessly off stage as all non-actors. Instead of teaching organization of materials in their technical, everyday application, the depictive arts teach the aesthetic treatment of watercolours. Poetry exists for declamation, and not for the organization of common speech. And so on, and so forth. In short, bourgeois art organizes the materials of life outside their practical application; it organizes them not for action, but for contemplation, for passive, static consumption that can only contribute indirectly to the organization of life.

Only after the socialization and technicization of the methods of artistic creation is it possible to introduce those methods into the system of proletarian pedagogy, where they will become an instrument for educating a person who is consciously organizing both the forms of his activity and the forms of the material environment. This means that actor training programmes must be reinvented so that theatre instructors can teach people how to walk in the street,

2. Dalcroze eurhythmics, which was developed in the late nineteenth century, is a form of musical training through physical movement (eds).

organize holidays, make speeches, behave in given situations. There should be a similar reorganization in poetic training so that instructors of the artistic word could teach the writing of articles, reports, etc. The entire field of art must be revolutionized so that artistic creation could become a means for organizing any sphere of life, not in the sense of decoration but purposive formulation – to an extent necessary for and according to the capabilities of the regular member of society, i.e., within the limits of individual practice (the rest will be formulated by professional artists).

In bourgeois society there are occasionally those who, within given bourgeois forms, introduce aesthetic moments into the practice of life. They are often called people 'with taste' and 'pedigree', who have 'style', a sense of form. But these people are, first of all, solitaries, and second, they are individualists both in their taste and in their style. They follow the general methods of bourgeois art: the principle of 'decoration', ostentatious effects, stylization through historical forms that are alien to modernity. They do not fuse their own instincts of form organically with the forms of reality, but try to impose on reality their subjective needs, which brings about a conflict between 'dream' and 'reality' which is especially common for these individuals (Oscar Wilde is the most acute expression of this).

The working class, which is going to carry out the conscious fusion of the aesthetic with the practical, the formal with the purposeful, will take a different path – the path of objective purposefulness of the formal organization of life, the path of holistic relation and holistic direction of all concrete elements of reality. To achieve the full sensation of reality, to become fully aware not only of the purpose of activity and the technique of its achievement, but also the form, the concrete

realization of reality – all of this means reaching such a state of socio-aesthetic monism where every phenomenon, every object is both constructed and perceived as a live, practicable organism ('construction', as opposed to the bourgeois 'composition'), i.e., is built and perceived collectively.

Only in this way – and no other way – is it possible to achieve in society the concrete monism of world perception and practice – that which is commonly called 'joy', 'creative fulfilment', 'harmony' of life, 'beauty'.

Art and Everyday Life

Any life, including social existence, is mutable, fluid, susceptible to evolution. Its activities continuously evolve in this or that direction – and consequently, the productive forces of society evolve in similar fashion. However, life activities in general and the productive forces of mankind in particular must be somehow stabilised – otherwise there would be a complete disorganization, 'absolute' anarchy.

Everyday life is a form-generating force in the development of social being. Everyday life is a system of more or less stable skeletal forms into which social existence is condensed at any given moment.

In bourgeois society everyday life was formed spontaneously, unconsciously; it ossified into static and conservative forms: established models, etiquette, a tradition of tastes, habits, norms, and manners. Bourgeois society did not generate any specialist organizers and creators of everyday life, organizers who would push everyday life along the path of social development, consciously and systematically change the *forms* of being, based on the tendencies of its *moving forces*. Moreover, bourgeois science decisively rejected the very possibility of

humanity's conscious impact on such phenomena as forms of language, types of behaviour, means of material everyday life arrangement, etc. All of these could have been organized by artists, as artists are the conscious inventors of forms. But as I have already shown, artistic creation in bourgeois society is removed from the sphere of social practice, from the general system of production, and, therefore, from the system of production of the means of consumption that make up the elements of everyday life.

Nevertheless, everyday life in bourgeois society kept evolving, but the evolution was rather spontaneous, unconscious, with jolts, hectic expenditure of huge reserves of energy, inevitably prolonged periods of the overcoming of rigid traditions. The engine of everyday life was mainly technical progress. But the organizers of technique never engaged with the task of forming everyday life; they were resolving purely technical problems, while everyday life was restructured to fit in with the technical reorganization, i.e., it was restructured obliquely, accidentally, without any system. From here you have what is typical of the bourgeoisie – either extreme individualization of the forms of everyday life, or their conversion into fixed models.

What is more, technical progress, while changing the material forms of everyday life, was leaving social tastes and the sphere of pure consumption in a relatively backward state, due to the fact new material forms were being perverted in a reactionary manner, being covered with traditional decorations, chased out of private residences, declared 'anti-aesthetic', and so on. It is curious, for example, that in contemporary America – a model for other countries in the sphere of technique – there is a desperate pull towards archaism in everyday life, towards a stylization after the exhausted European forms of the

Post-Impressionists, etc. Train stations, automobiles, factories were once considered to be 'vulgar' in capitalist society; they used to cover them with 'antique' shrouds, to kill their formal independence. The new technique has begun to win over the social-everyday archaism only after a long interval of time, breaking the forms of everyday life, reorganizing tastes, and creating its *own* aesthetic. This marks the advent of the next phase: the newly emerged forms gain a foothold, become habitual, ossified, and they need to be overcome anew through a destructive, anarchic, method-blind struggle against the 'customary'.

The other organizer of everyday life was art. But as long as it was merely added to everyday life, only decorating it or leading away from it, as long as the easelist, depictive forms merely (illusorily) supplemented everyday life, the organizing role of the artist was either extremely weak and indirect or reactionary. Instead of revolutionizing the forms, the artist archaized (stylization) and sanctified (naturalism) them. He placed an aureole of 'beauty' on everything that had already ossified, instilled love for anything expired or already existing, taught the 'statics' of taste. In cases when art advanced new forms, they triumphed, only after a mutually devastating struggle between different advocates of 'taste', and therefore, they only triumphed partially. The whole history of art over the last hundred years has been a rabid hounding of innovators and misunderstanding and discord between producers and consumers of artistic values. Yet, even after winning, the new artistic tendencies, limited by the narrow field of easelism, could not substantially influence the whole structure of everyday life. Everyday life evolved outside of art, outside of the conscious creation of forms.

The working class, monistically organizing social existence, will be consciously, systematically and continuously changing the forms of everyday life. Proletarian everyday life, which is tightly connected with the evolution of production, is fluid in its tendencies; its focus is not on any tradition but on the maximal fitness, maximal purposefulness of forms, their flexibility and mobility (plasticity). To the extent that the proletariat will master its own activities, to the extent that its organizational actions will spread across all the realms of life – the proletariat will have to move from spontaneity to a normalized change of everyday life. And that is possible only in one case: if artists desist from decorating or depicting everyday life and start *building* it. The complete fusion of artistic forms with the forms of everyday life, the complete immersion of art into life, the creation of a maximally organized and purposive and endlessly creatable being will bring not only harmony to life, the most joyful and fullest deployment of all social activities, but it will also destroy the very concept of everyday life. Everyday life understood as something static, ossified, will cease to exist, as *the forms of being* (as they appear in everyday life today) will change constantly with the change of the productive forces.

The creation of forms will merge with practical creation, and this will put an end to the enormous expenditure of energy; the skeletal chains that were stopping social evolution will crumble, and the tempo of social development will be unprecedented in pace.

To build everyday life means to take equal part in social production – mainly, in the production of the means of so-called productive consumption, which includes transportation, construction facilities, clothes, utensils, practical literature, and so on.

The entrance of the artist into production as an engineer-constructor is significant not only for the organization of everyday life, but for technical development as well. The history of technique shows that its progress was drastically slowed down by the conservatism of skeletal, material forms of the technical product. The engineer-inventors, who are mostly weak in the sphere of formal creation, always had to proceed from existing forms in any technical innovation; the forms evolved slowly, with difficulty under the pressure of technical tasks. A good illustration of this is the history of the automobile: we know that the first automobiles were ordinary carriages fitted with engines; the elements of the new form were created only over time, whereas before that the technical projects were weak and almost did not progress beyond what the old form could offer. The artist-engineer, who invents forms of objects on the basis of organic collaboration with the inventor-technologists, will liquidate the formal-technical conservative energy and free technical development from the regime of the model.

But that is not enough. The problem of socialist production, which has to be solved by the proletariat, is a problem of complete coordination between production and consumption. Until now such a coordination was viewed from a purely quantitative standpoint. More specifically, capitalists spoke about the correlation between the quantity of production and the quantity of demand. Meanwhile, the quantity of labour (value) is the only economic category in a commodity economy (exchange value); in a natural economy, and therefore in the socialist economy, it is the quality of labour (use value) that will be taken into account. In other words, the producers in a socialist society will have to orient their activity towards how their products will function in society – they will have to care

about the life of their products after production, about their qualitative meaning for the consumers.

But the quality of labour is nothing other than the methods of products' formation. The quality of a product is its form, its construction. Socialist production, therefore, has to coordinate the form of products with the forms of their practical-utilitarian use.[3] And this is precisely the task of artistic production – a task that can be carried out only by engineer-artists who simultaneously create the forms of 'everyday life' and the forms of the products they produce.

The activity of the artist-engineer will become a bridge from production to consumption, and therefore an organic, 'engineeresque' entrance of artists into production becomes, among other things, a necessary condition for the *economic* system of socialism, which is becoming more and more inevitable as we move towards it.

Depictiveness in Art

The complete fusion of the social process of production with artistic creation is possible only to the extent to which society will be socialized. This development will attain a creative, artistic form only when humanity develops its productive forces collectively and in a planned way.

So long as society remains even partially unorganized, so long as it preserves at least some elements of spontaneity and unconsciousness in its development, artistic creation will be impossible within the boundaries of these elements, which means that this part of artistic creation will be realized outside of utilitarian 'building', and will be added to it as a supplement.

3. This problem is already being addressed: the fight for the quality of production.

Regarding so-called 'applied' or decorative art, there is no need to prove that it serves as a supplement to reality: one 'decorates' only what is 'not beautiful' in itself, anything that is directly unsatisfying, i.e., not holistically organized.

However there is another, more widespread type of artistic supplement to reality, the so-called depictive arts (paintings, novels, films, etc.).

This kind of art, with the help of depictive fantasy, with the help of combinatorial ('compositional') activity, allows people to see, hear, feel in an organized way that which is not organized in their own lives, but which compels. Depictive art fulfils in the imagination those social needs that are not realized in reality.

Let me give a few examples.

The entire realm of artistic subjects can be roughly divided into the following groups: 1) depiction of nature, 2) depiction of objects, 3) depiction of the human being, 4) depiction of human activity.

Let's begin with the first one.

It is important to note, before anything else, that no agricultural epoch, i.e., no epoch of practical direct connection with nature, has ever created a single painting, a single literary landscape. Likewise, the peasant art of the subsequent epochs does not know what landscape painting is. Landscape painting appears and develops in art simultaneously with the appearance and development of the urban bourgeoisie, i.e., the class that tore itself away from the practical connection to nature. Since there was a need for such a connection, a pull towards nature, art satisfied this pull through depiction. So, for example, the first painting of the Italian Renaissance, in which the landscape played an important role, coincided in the time of its creation with the first picnics of city dwellers.

And the landscape of the Venetian Renaissance was signifi-
cantly richer than in other cities because of swampy Venice
– the Venetians were passionately drawn to the 'terra ferma'
(mainland), a meadow in a forest was regarded as something
very beautiful.

And later in France, where painters served the feudal
aristocracy, a landowning class that had settled in the city, the
landscape became idealized: their own nature seemed too 'base'
and French artists derived their landscape compositions from
the exotic and imaginary landscapes of the Italians. The pure
landscape blossomed only in the epoch of capitalism, when
society finally fenced itself off from nature and knew it only
from 'the country house' life. Initially they depicted forests,
fields, mountains, seas, rivers, but when factory production
and multi-storey buildings chased the light and air out of the
cities, the Impressionists appeared – the depicters of light and
air. Landscape painting is dying in our epoch of urban tree
planting and garden-city planning.

Next, the depiction of objects.

All epochs of natural and craft economies have almost no
paintings depicting objects; people who created real material
objects had no need of their pictorial reproduction. On the
contrary, they gave people and nature specifically objectal
features (Greek sculpture of the sixth century; Italian landscape
painting of the fourteenth century, etc.). But starting with
the epoch of mercantile capitalism, and wherever mercantile
capitalism was in full bloom, we see the emergence of the
depiction of objects. These depictions were made by bourgeois
artists, meaning artists who belonged to a class that distanced
itself from production, but which preserved an acute sense
of objectal ownership (later this ownership instinct took a
monetary form). The individualistic love of the object, the

compulsion to own it, to show it and to see it – found its expression in the works of painters.

The depiction of objects is revived once again only towards the end of the nineteenth century. With the creation of large industrial centres, the development of new techniques, and the emergence of technicism, the world of objects acquired a new aura (Americanism, the pull towards the most advanced material culture) in the eyes of the bourgeoisie (the novels of H. G. Wells). The bourgeoisie loved the object of art to the extent that it was able to sense the tendencies of technical development, which it had not yet really mastered (curiously, the most powerful painter of the object, Paul Cézanne, spent his entire life in a provincial semi-rural town). The artists of the twentieth century who consciously chose the path of technicism, on the contrary, abandoned the depiction of the object and took over the treatment of real materials.

I will mention cursorily some analogous facts concerning the depiction of the human being.

So, for example, in ancient Greece, sculptures of so-called beautiful bodies appeared when the Olympic games – an organization that produced harmoniously developed human beings – were stopped.

The nude body was depicted not in those epochs when it was a part of the common phenomenon of everyday life (for example, Egypt, Japan), but, on the contrary, when etiquette forbade open nudity (for example, the paintings of Rubens in France during Napoleon III, etc.), whereas the pull towards the erotic or sensual unfolding of life in general was very strong.

Portraiture reached its peak in the historical period when persons were maximally atomised, in the period of extreme individualism (the sixteenth century, or the end

of the nineteenth century); the artist's portrait gave people the opportunity to experience another, different personality, thereby satisfying the heightened interest in the life of another person – an interest that could not be satisfied in practice.

The same could be said about the depiction of everyday life in art: the more disorganized everyday life became, the more disharmonious or further from people it was, the more there was interest in it, and, hence, art focused more on the depiction of everyday life (Dutch genre painting, the Itinerants, etc.). It is understandable, therefore, that bourgeois artists frequently portrayed the so-called 'folk' or 'aristocratic' everyday life. The purely bourgeois depictions of everyday life have dominated for only a few decades in the nineteenth century – the epoch of the dissolution of everyday life, when the city had not yet collectivized masses of people (the artistic development of this period at a time that saw the triumph of Manchester-ism is not coincidental). Artists harmonized in depiction that which was disorganized in the experience of the social layer that they were serving.

These facts bring us to conclusions that are extremely important for understanding the meaning of artistic creation.

Since art does not 'reflect' life, as it is commonly thought, but rather supplements it, since the artist harmonizes through one or another device what is not harmonized in reality – it means that any type of depictive art represents, in the very rationale of its social task, a rearrangement of reality, its transformation. It means that the role of the depictive artist is to take the elements of life and change them in his own way, bring them out of their usual everyday context in order to let us experience them anew. Thus, authentic naturalism, 'truthfulness' in art is a myth that has never been and will never be realized. 'Real' depictive art is a *contradictio in adjecto*, and so-called 'realism'

is merely a special mode of artistically changing reality – a mode, by the way, that is used unconsciously.

This is why charging art with the task of fixing reality (for example, the reflection of everyday life) is anti-scientific and practically ineffective. Although it is true that, in spontaneous societies, depictive art was a means for concrete cognition of reality, this type of cognition was both partial and subjectively distorting. As soon as technology created methods for exact description and measurement, they squeezed art out of its cognitive positions: photography and film have killed portrait, landscape and genre painting, while journalism has killed the literature of everyday life.

The proletariat must obviously know life not only abstractly (scientifically), but also concretely, in all its reality. But for the proletariat this is not a question of art, as some arbitrary beginning, but a question of the purposive, precise, scientifically planned organization of life. The reflection of everyday life is a problem that must be solved within the field of science (dialectical method) and technique: photography, cinematography, the phonograph, museum, literary protocols of everyday life – in other words, an objective fixing plus a dialectical montage of actual facts, instead of a subjective combination of made-up facts on which depictive art is constructed and without which it is unthinkable.

Regarding depictive art – its survival depends upon the survival of social disorganization. If, in a socialist society, unaccomplished goals will be technically prepared and scientifically analyzed, in a partially disorganized society there will always be groups demanding a concretization of tasks and their imagistic realization, even with the help of fantasy. Besides this, the disorganization and partial ossification of everyday life will generate the need to supplement the

everyday with forms of depiction. In other words, before the advent of socialism, the proletariat must use depictive art as a special class-organizing profession.

The bourgeoisie employed art unconsciously, without really understanding its supplemental social role. The proletariat, on the contrary, must consciously approach depictive art, having in mind its true nature. Instead of obfuscating the supplemental function of art, we must genuinely reveal it – otherwise, it would be an illusory withdrawal from reality, a harmful self-deception, a pseudo-life convenient for the bourgeoisie, but dangerous for the class of real builders. The working class must introduce into the task of art the conscious laying-bare of the organizing function through the very *form* of the works – a conscious utilitarianism.

Since the art of depiction supplements reality, it is necessary to make this supplement actively class-based. However, actively supplementing art is nothing other than agitational, propagandistic art: it propagandizes what the organizers desire, but what has not yet been realized.

Bourgeois depictive art was easel art; it rested on the self-sufficient fundament of individualistic forms and was intended for contemplation. Proletarian depictive art, as long as it is conceivable, must tightly connect with social practices and turn into an art of social impact, i.e., into an art that would seek to trigger specific, concrete acts. However, it would not suffice to connect the forms of proletarian art with 'proletarian building' only thematically. It is necessary for these forms to penetrate directly and materially into the workers' everyday life, revolutionizing it from within. It is necessary not to take the workers' everyday life onto the theatre stage, but to extend the theatre stage into everyday life. Instead of salon romance songs we need the emergence of songs for mass dissemina-

tion in everyday life. The proletarian artist must be the equal builder of everyday life and not a priest of art. It is necessary for him to be a model for every worker, so that the products of his labour and the methods of his activity are adopted everywhere.

Revealing the devices of artistic mastery, the liquidation of its fetishistic 'mystery', the transmission of devices from the artist-producer to the user – this is the only condition that will help to erase the centuries-long boundary between art and practice. Artistic products, existing in everyday life and evolving along with it, no longer stand out as 'unique' artefacts and are not conserved as absolutes. The obsolete object will be replaced by the new one; the fetishism of art will collapse, as the 'mystery' of artistic creativity will be revealed and understood henceforth as the highest form of mastery.

Naturally, this kind of revolution in artistic worldview revolutionizes the very consumption of artistic values. The work of art will be accepted not because it responds to the established formal tastes (bourgeois canons), but because it will be made masterfully in the given case and for the given task.

Such a revolution also necessarily brings about the destruction of museums as storehouses of 'eternal' individual values. Instead of museums there will be general scientific repositories with a historically necessary and a pertinent selection of examples. They will not admire and copy objects in museums, but conduct research.

* * *

Whether art can survive in a socialist society is a separate question in relation to the general problem of depictive art. Based on what has already been said, it is possible to claim

that in an organized, holistic social system depictive art, as a separate, specialized profession, will wither away. Unrealized social needs will be prepared technically and scientifically in a planned and conscious manner, not in a compensatory fantasy.

And yet, as absolute organization is practically unattainable, and as the elements of disorganization remain in the private lives of the members of socialist society, it is possible to think that depictive supplementation will remain under socialism as well, but it will transform into a purely personal, not fixed, form of self-exposure in social everyday life. In such artistically organized self-exposure and communication, the human personality will apparently compensate for its partial discontent. Depictive art will also be preserved in children's creation, repeating in the individual evolution the evolution of mankind. Both cases will be governed by the improvisational method of creation, made possible due to the harmonious upbringing of the personality in a collective.

Afterword

The 'Electrification of Art': Boris Arvatov's Programme for Communist Life

Alexei Penzin

I. *'Comrade Boris Arvatov'*

Comrade Boris Arvatov is a worker of proletarian culture, who gives all his energies to the working class and communism. His intense theoretical and practical activity never ceases even for a minute. He published numerous articles on the issues of art, theatre and literature in a number of journals and newspapers (*Press and Revolution, Gorn, LEF, Proletarian Culture* and others); he also published a collection of articles titled *Art and Classes*, and had prepared for publication a monograph on Mayakovski and Nathan Altman. Together with this literary activity, he continued an intense research and teaching. In recent times, he has been overworking, and some shocks heavily affected his health, so destabilising of his nervous state was a real threat. Following the medical advice, he took the decision to spend some time in the sanatorium.[1]

1. *LEF*, 1923. N 3. p. 40.

It was Nikolay Chuzhak, Arvatov's fellow thinker in the circles of LEF and Production Art, who wrote this comradely and enthusiastic piece of revolutionary prose about his work and life in the first half of the 1920s. This paragraph was a part of a larger text – an open letter, signed by Sergei Tretyakov, Osip Brik and other members of LEF, published in the journal in summer of 1923.[2] The signees expressed their indignation caused by an outrageous case at the time – an opponent of the LEF programme had speculated in a denigrating feuilleton about Arvatov's nervous breakdown, allegorically projecting his troubled personal circumstances onto the whole avant-garde movement.

This document, from a dramatic episode from the struggles of the avant-garde in the 1920s, provides an affecting insight into the life of Arvatov. The LEF open letter is a unique source, given that published biographical materials on Arvatov are scarce. With the exception of several page-long articles in literary encyclopaedias one can hardly find anything on the theorist, even in Arvatov's native Russian.[3] We certainly know that Arvatov's breakdown happened three years before the publication of *Art and Production* and seven years before he suspends his intellectual career, spending the next ten years

2. It was also Nikolay Chuzhak who introduced the notion of 'life-building' into the avant-garde, the key concept of Arvatov's theory of art. See N.F. Chuzhak, *Under the Banner of Life-Building (An Attempt to Understand the Art of Today)*, trans. Christina Lodder, *Art in Translation*, 1:1, 2009, p. 119–151 (originally published in the journal *LEF* in 1923).

3. Some personal letters, documents and manuscripts by Arvatov are saved in the Russian State Archive of Literature and Art; work on a detailed biography would be a necessary future task. See also an elaborate biographical note on Arvatov in, Christina Kiaer, 'Boris Arvatov's Socialist Objects', *October*, Vol. 81, 1997, p. 106–107.

in psychiatric sanatoriums where, allegedly, he committed suicide in 1940, aged 44 years.

The initial cause of Arvatov's mental suffering was the after-effect of shell shock that he experienced during the Civil War, when he served in the Red Army as a commissar. Arvatov became a member of the Bolshevik party in 1919. Around this time his first articles were published in various periodicals of the Proletkult – the movement for an autonomous proletarian culture based on the historical and labour experience of the working class, which self-consciously distanced itself from the old ruling class culture. In 1921 he joined INKhUK (the Institute of Artistic Culture) and took part in many discussion-groups, committees and meetings as a representative of the organization. In 1923 he was also one of the co-founders of LEF. Thus Arvatov's period of active intellectual engagement continued for only eleven years. Remarkably, given that he was so young, (he was intellectually active mostly between 23 and 34 years old), Arvatov published about 100 articles and reviews, and five books – *Art and Classes* (1923), *Nathan Altman* (1924), *Art and Production* (1926), *Sociological Poetics* (1928), *On Agitation and Production Art* (1930). Marked by tragic intensity, his life gives an image, therefore, of a truly militant communist thinker who lived through an exceptional decade of cultural experimentation after the October Revolution. One of his LEF colleagues called him 'Saint-Juste of the Avant-Garde'.

II. Influences and Readings of Arvatov's Legacy

Arvatov's books were not republished in the Soviet Union and neither have they been republished in 'post-communist' Russia – although during the Soviet 1960s and early 1970s,

in the period of partial de-Stalinization, there were several monographs and doctoral researches about Production Art. This material, however, did not focus exclusively on contributions by Arvatov, interpreting the Production Art legacy from the point of view of a depoliticised theory of design, rather than as a radical avant-garde programme, given that this might have appeared as contradicting the late Soviet ideology of 'mature socialism'.[4] *Art and Production* though has been relatively well served by translations, being translated into German (1972), Spanish (1973), Italian (1973), and now finally into English.[5]

In the international reception of the Soviet avant-garde in Slavic Studies departments, Arvatov, Chuzhak and other avant-garde and Production Art fellow-thinkers, such as Sergei Tretjakov, are mostly discussed in relation to theories of the 'total transformation' of everyday life under socialism, in contexts definitely alien to the Production Art theorists' own intentions and ideas. According to these authors, Production Art anticipates the 'totalitarian' domination of later Stalinist politics over all aspects of society and everyday life.[6] Or, even

4. It is worth mentioning here the monograph by Anatoly Mazaev, *'Konzepzia 'proisvodstvennogo iskusstva'. Istoriko-kriticheskii ocherk'*, 1975, [*The Conception of 'Production Art'. Historical-critical Essay*], and the works on Production Art and Arvatov by art historian, Elena Sidorina, published from the 1970s to the 1990s. In a post-Soviet academic context, the only exception is the book by Igor Chubarov, *Kollectivnaya chuvstvennost': teorii i prackiti levogo avangarda [Collective Sensibility: Theories and Practices of Left Avant-Garde]*. Moskva: Visshaya shkola economiki, 2014. The book has a chapter entitled, 'Conceptions of Production Art', which provides a contemporary reading of Productivism, including the ideas developed by Arvatov.

5. *Kunst und production*, Munchen, 1972; *Arte y produccion*, Madrid, 1973; *Arte, produzione e rivoluzione proletaria*, Rimini, 1973.

6. For example, in his widely acclaimed *The Total Art of Stalinism*

worse, ideas about 'life-building' are considered to be a sec-
ularisation of obscure religious discourses, 'theurgical' and
messianic currents of Russian pre-revolutionary mysticism
and theology that were obsessed with the idea that humans
can occupy the place of God and initiate a 'life-creation'
process in the end of history.[7]

Art history and art theory are more nuanced, and as
such are not so charged with anti-communist sentiments
and assumptions, that in Slavic Studies tend to decontex-
tualize the ideas of Arvatov and his fellow-thinkers.[8] The
most interesting and sympathetic of these accounts are
those shaped by the discussion of the connections between
leading European Marxists, such as Walter Benjamin, who

(Princeton, 1992), Boris Groys discusses Arvatov's *Art and Production*
as anticipating a Stalinist 'Gesamtkunstwerk' of fully-organized social
reality (pp. 25–27).

7. Nikolay Chuzhak, who coined the term 'life-building', indeed might
have been inspired by some representatives of those currents in his text
'Under the Banner of Life-Building', such as the important philosopher
and theologian Vladimir Solovyov. But Chuzhak definitely did not
imply, supported by some scholars, that 'Russian communism' was a
secularization of prerevolutionary theological thought. Arvatov never
refers to these religious discourses that were still popular in the early
1920s atmosphere; his main theoretical references are Marx and the
outstanding Bolshevik philosopher Alexander Bogdanov.

8. Such as the books by Maria Gough and Christina Kiaer. Another
exception is the work of Italian scholar, Maria Zalambani, who
published an article on Arvatov in French ('Boris Arvatov, théoricien
du productivisme' in *Cahiers du monde russe*, 1999, Volume 40, Numéro
3). See also her *L'arte nella produzione. Avanguardia e rivoluzione nella
Russia sovietica degli anni Venti*, Longo Editore, Ravenna, 1998, which
contains a chapter on Arvatov and Bogdanov. Generally, Zalambani
gives a detailed historical contextualization of Arvatov's work, but
without much argument about his significance for contemporary
critical theory and aesthetics.

were contemporaries of Arvatov and his co-thinkers. These connections are already well established and much discussed, drawing attention to the fact that it was Sergei Tretyakov and Arvatov who influenced Benjamin's classic texts, 'The Work of Art in the Age of Its Technological Reproducibility' and 'The Author as Producer'. As Arvatov claims in *Art and Production*: 'The proletariat will inevitably arrive at the *socialization of artistic labour...' 'Instead of socializing aesthetics, the scientists aestheticized the social milieu.'* Catchphrases like 'socialisation of artistic labour' or 'socialising aesthetics' used in opposition to the 'aestheticizing of the social milieu' immediately recall Benjamin's famous slogan: '*Such is the aestheticizing of politics, as practiced by fascism. Communism replies by politicizing art.*'[9] Benjamin did not explicitly acknowledge that his '*politicizing of art*' claim was derived from his Moscow exchanges and experiences. But given that Arvatov's book was published in 1926 – the same year that Benjamin travelled to Moscow and was able to assimilate a number of ideas from many private conversations with the key figures in the capital's avant-garde scene – the connection is clear.[10] As research on Benjamin

9. W. Benjamin, *The Work of Art in the Age of Its Technological Reproducibility, and Other Writings on Media*, Harvard University Press, Cambridge, Massachusetts, 2008, p. 42.

10. For this aspect, see Maria Gough, 'Paris, Capital of the Soviet Avant-Garde', *October*, 2002, 101, pp. 53–83. Gough carefully reconstructs the connections and intellectual transfers between Tretjakov, Brecht and Benjamin. Although Gough never mentions Arvatov, given that Tretjakov and Arvatov belonged to the same circle of LEF and then 'New LEF' from at least 1923 to 1928, it is not too difficult to imagine that Tretjakov could have informed his German left friends about Arvatov's ideas. In addition, according to Gough, Tretyakov went on an extensive lecture tour to Germany and Austria in 1931, and his lectures instigated vivid debates among local left intellectuals. Benjamin could have been among the attendees of these lectures. The

and the Soviet avant-garde demonstrates, Benjamin treats the Soviet theorists with a slightly 'paternalizing' attitude, considering them, as in the case of Tretjakov in 'Artist as Producer', as generic 'examples' of advanced practice and not as leading theorists whose ideas had informed his thinking.

These ghostly borrowings and transfers of ideas reveal some subtle nuances. In the light of the massive social and technical changes initiated by the October Revolution, Arvatov and Tretjakov depart from traditional Marxist aesthetics. The 'socialisation of art' is considered as an integral part of the large-scale process of the general socialisation of means of production and everyday life. Benjamin in contrast – in the different atmosphere of the 1930s and the catastrophic advance of fascism – 're-functions' (to use his friend Bertolt Brecht's favourite expression) the 'socialisation of art' as the 'politicizing of art', as it was pointless to speak of 'socializa-tion' without revolutionary transformation and a socialist government. At that time this sounded like a rather weak appeal, and acquired its contemporary status as a canonic quote much later, after the posthumous publications of Benjamin's work and the demise of the Soviet avant-garde.

After the translation of *Art and Production* into several European languages in the early 1970s, it was difficult to ignore Arvatov's theoretical contribution. For example, in his now standard *Theory of the Avant-Garde* (1974), Peter Bürger

similarity between Benjamin's 'politicising art' formula and Arvatov's 'socialising aesthetics' is also briefly noted in Igor Chubarov's book *Collective Sensibility: Theories and Practices of Left Avant-Garde*, Visshaya shkola economiki, Moskva, 2014; the links between Benjamin and Arvatov's in relation to the notion of the everyday are stressed in John Roberts's *Philosophizing the Everyday. Revolutionary Praxis and the Fate of Cultural Theory*, Pluto Press, London, 2006.

mentions Arvatov and Tretyakov in passing in the footnotes, acknowledging Arvatov's historical account of the 'bourgeois art' as 'similar' to his own, published almost fifty years after.[11] Indeed, the whole argument of Bürger's book sounds similar to some of Arvatov's ideas and terminology. Bürger distinguishes the avant-garde from modernism (understood as an institution of the autonomy of art), and sees the historical avant-garde as at the forefront of the attack on this institution, inspired by 'the principle of the sublation of art in the praxis of life.' In *Art and Production* Arvatov uses the term 'praxis of life' and describes bourgeois art with expressions such as 'isolated', a 'separate, self-contained world', and 'detached from life'. Arvatov did not apply the term 'autonomy' itself to define bourgeois art, as it only came into common usage after WWII in the post-Kantian contexts of Adorno and Greenberg's critical defences of the term, produced in a completely different historical situation.[12] And of course, in this light, Arvatov's historical account differs dramatically from Bürger's. It is a lucid post-revolutionary *tour de force* aiming at the complete closure of any ambiguities about any political and aesthetic potential in the value of 'autonomy'. 'Autonomy' is interpreted as a mere functional outcome of capitalist modernity, and as such, given its inability to 'build' life, it leaves no doubt that its detachment of art from praxis should be abolished under conditions of non-capitalist society.

In the Anglophone reception of Arvatov after Bürger, Arvatov is currently perhaps better known through the translation of a text related to *Art and Production*. In 'Everyday

11. Peter Bürger, *Theory of the Avant-Garde*, University of Minnesota Press, Minneapolis, 2009, p. 112–114.

12. Needless to say, that Adorno's and Greenberg's defences of 'autonomy' had very different structures of argument and political valences.

Life and the Culture of the Thing (Toward the Formulation of
the Question)' he elaborates a theory of non-alienated 'socialist
objects' viewed as dynamic elements of a new everyday life, or
even as 'comrades', as opposed to 'dead' commodities.[13] Linked
to his theory of Production Art, these 'socialist objects' pose
the question of the communist 'use' of everyday things, in a
way similar to the question of the communist 'use' of art that
leads towards its dissolution in social production.

III. 'Build' or 'Depict'? The Genealogy
of Art's Relation to Production

In the second half of this afterword – assuming that the
reader has already familiarised herself with the text of Arvatov
– I would like to emphasise several important points in *Art
and Production* that are still little-discussed by commentators.
Also, beyond the narrower issues of the Marxist theory of art,
it is worth stressing here that Arvatov's programme resonates
with some key problems of contemporary radical thought and
must be read within this broader framework.

The first point is Arvatov's original genealogy of relations
between art and production. He argues that the new art
should overcome its isolation in society and become an
essential part of social production. But Arvatov's powerful
historical-theoretical narrative is supposed to prove that art,
since early capitalist modernity, *always* kept a relationship –
positive or negative, immediate or mediated – with production.
The pre-modern artist was already 'dissolved' in crafts guilds
that were full-fledged organizers of life and production. The

13. Boris Arvatov, 'Everyday Life and the Culture of the Thing (Toward
the Formulation of the Question)', trans. Christina Kiaer, *October* 81
(1997).

development of early capitalist manufacture and specialisation of labour, however, created a gap between artist and craftsmen; later, machine production leaves the artist only the role of an external decorator in the processes of life and production. Finally, the easel painting became an ideal commodity for the market, given that it was fully separated from any organizational and collaborative activity, leaving the artist in an archaic and individualistic mode of practice. The key term of Arvatov is '*stroitel'stvo*' (literally, 'building') understood as an organizational force that under capitalist conditions belongs mostly to the ruling or 'managing' classes.[14] Art's organizational, 'life-building' potential is marginalized, therefore, by the market and ideologies of creativity that reduce art to the commodity production of representational, or 'depictive' artworks. The artist's activity remains in a technically and socially backward state that suppresses the organizational, life-building potentials that otherwise could reach far beyond the artist's studio walls. In Arvatov, 'depictive', representational art is close to what Marx calls 'dead labour', i.e., objectified and commodified products of the labour process, while the subjective aspect of 'life-building' means something close to what Marx calls 'living labour'. The 'depictive', representational artwork, culminates in the form of easel painting that always emerges in the place of formerly living and now vanished activities. As a result, it compensates or supplements the lack of organization in social life.[15]

14. In Russian, '*stroitel'stvo*' means literally 'building', but also, in a metaphorical sense, could mean 'construction', 'organization', and 'creation'. For example, the recurrent topic of Soviet public discourse was the 'building of socialism'.

15. So for Arvatov, it is not art's belonging to the residual elements of religious ritual that makes the artwork 'auratic', as Walter Benjamin suggested, but rather its separation from life and production.

Thus Production Art was not effectuated only by the rev-
olutionary rupture of the 1920s; the organizational potential
of art was able to realize itself to a degree, in the bourgeois
époque. Consequently, given this historical experience, there
is nothing 'utopian' in the idea that art can 'fuse' with life (or
production). In a non-capitalist context, art, therefore, can go
beyond 'depictiveness' and become fully open to 'life-building'.
In his *Art and Production*, Arvatov calls this new mode of
operation of art its *'electrification'* – a colourful metaphor, that
in referring to Lenin's tactical definition of communism as,
'Soviet power plus the electrification of the whole country',
implies a re-activation of the grid of historical potentialities
that are already embedded in art.

It is important to explain here – in a simplified form – from
where Arvatov's ideas on organization emerge. Its philosoph-
ical origins, as we mentioned already in a footnote to the text,
are in Alexander Bogdanov's teaching on organization and
'proletarian monism'.[16] According to Bogdanov, ontologically,
the monist view presents the universe as an immense web
of various forms and levels of interconnective organization,
which are as immanent to enormous star systems as they
are to human societies. All these forms and levels shape a
continuous and universal 'world-building' process. At its
specific level in this bigger cosmic picture, the capitalist
society is profoundly disorganized, subject to the 'spontaneity'
of elemental forces of market competition, while the new
communist society provides the introduction of organization

16. Arvatov discussed Bogdanov's work in his early text 'Review of
 Boganov's Lectures of 1919' ('Rezenzia na lekzii Bogdanova 1919
 goda', in *Pechat I Revoluzia*, 6/1922). For Bogdanov, see his recently
 translated work, *The Philosophy of Living Experience*, published in the
 Historical Materialism Book series (Brill, 2015).

into all aspects of life and production. For Bogdanov, the rise of proletarian culture introduces a new form of 'monism' that is alien to bourgeois society with its separation of the material, practical and ideal, based as it is on the fundamental division between those who organize and those who perform various tasks set by organizers.[17] Proletarian experience is monist, because it is linked both to the creative, organizing functions of workers' use of machinery, and to workers' manual skills in the fulfilling of various productive tasks. Proletarian monism also derives from the implicit 'comradely cooperation' in the labour process that communism then transposes into a new proletarian culture.

As a theoretical consequence of this teaching on 'proletarian monism' art should respond specifically to the problem of organization and disorganization in social life.[18] It can respond directly – by intervention into life with a given set of techniques and means – or it can provide, in a 'depictive' way, models or examples of 'good', harmonious organization that compensate or supplement the lack of organization in real life. The second mode prevails under capitalism; the first mode emerges in post-capitalist society where art becomes one of the forces involved in finally dissolving production into 'life-building'. That is, given that science and technology have a direct impact on the forces of production (as Marx

17. See, for example, Alexander Bogdanov '*O proletarskoi kulture. 1904-1924*' [*On Proletarian Culture. 1904-1924*], Moscow, 1924.

18. In a sense, Bogdanov's and Arvatov's views on art anticipate Gilles Deleuze's philosophy of art in which the artist acts as a romantic and heroic organizer of a primordial ontological 'chaos'. But for Deleuze, the organizing force of art is not a direct intervention, a fusion with life; it is rather an individualistic, modernist mode of representational, 'depictive' practice that captures and stabilizes the chaotic movements of the real into various 'affects' and 'percepts'.

famously predicted in his *Grundrisse*), artistic technique has an important role in bolstering and empowering the productive forces, harmonizing its subjective and collaborative aspects, because 'art is the type of creation that extends the possibilities of an individual in a collective in the fullest, most harmonious way.'

So, according to Arvatov, there are two responses of art to the problem of organization. One is mimetic and representational ('depictive') and profoundly passive, whose operation consists of detaching an object from its use, its external life environments and corresponding human practices, in order to contain life within a compensatory imaginative representation. And another is practical, active, organizational, in which art is involved in the immediate creation of life forms. Art *is* 'life-building', a creation of forms of life, and therefore exists within a general 'praxis of life' as one of its essential matrices. Representational, 'depictive', or narrowly 'aesthetic' functions of art are thus merely secondary, the result of art being historically separated from the 'praxis of life' by the context of capitalist modernity.

IV. Communist Forms of Life

In the concluding paragraph of *Art and Production* Arvatov daringly hypothesizes about what will happen with art in the stage of full communism. According to him, art will *'wither away'* – an expression that Lenin famously used in 'State and Revolution', to describe what will happen to the State after transition to communism – yet at the same time, art will somehow persist in a sublated, secondary form, as it is impossible to eliminate all non-organized elements of everyday

life (such as individual discontent of various kinds).[19] So art can be used as an individual kind of 'self-exposure' of these non-organized elements in a 'depictive', representational way: '...as absolute organization is practically unattainable, and as the elements of disorganization remain in the individual lives of the members of socialist society, it is probable to think that depictive supplementation will remain under socialism as well.'[20]

Consequently, Arvatov declares that the communist 'fusion' of art and life is able to give to life a specific *form* or higher *quality* through the techniques derived from particular arts (visual art, literature and poetry, dance, theatre, music), producing the contours of a new 'flexibility and mobility (plasticity)'. Communist forms of life for Arvatov, then, would be a full merging of 'art' and 'life' without losing the qualities of both (both form and plasticity), producing an incredible fusion of newly-built empowering habits ('qualitative' walking, moving, speaking, etc.) and the moments of accelerated creativeness – a kind of non-theologically understood 'continuous creation' paradigm that overcomes the opposition between punctual 'creative acts' and intermediate everyday routines. The strangest

19. That is why the claims that Production Art theories anticipated later Stalinist 'socialist realism' and 'totalitarian' organization of society are not valid. They ignore Arvatov's subtle distinction between 'depictive' and 'direct' modes of art's 'life-building'. Arvatov and his fellow-thinkers mean precisely that art's 'life-building' under socialism is not compensatory and depictive (as Socialist Realism might be described) but is a direct *practical fusion* with life. However, 'life-building' cannot encompass all the meticulous aspects of individual life, as it was falsely exaggerated in the 'dystopian' presentations of 'real socialism'.

20. Arvatov also notes – perhaps, a bit humorously – that 'depictive' art '... will also be preserved in children's creation, repeating in the individual evolution the evolution of mankind.'

effect of these powerful considerations – especially in the context of the current global reactionary turn and profound scepticism about even moderate programmes for 'changing life' – is that they do not appear as something 'utopian' and unrealistic, but, on the contrary, as analytically and practically achievable.

We might ask then: does this set of ideas deserve the name of a communist 'biopolitics?' – even though the very term 'biopolitics' is now often no more than a vague theoretical catchword?[21] For without this connection, Arvatov's concluding, far-reaching hypotheses about the 'withering away' of art, would appear less radical, less interesting philosophically. He would just be another sociological Marxist theorist of art – of which there were many in the twentieth century – who steadfastly avoided asking such questions about the role of art in the wake of the enormous transformations – not only social but also ontological and anthropological – that were made thinkable and possible by the October Revolution.

Given that capitalism has now entered a new politically and ecologically toxic phase of development after the 2008 crisis, Arvatov's analysis from the 1920s takes on an even greater force and gravitas. Of course, it could be argued, implicit in Avatov is a belief in progressive technical and social 'developmentalism' that is undermined by the tragic vicissitudes of 'real socialism' that already started to unfold in the early 1930s. As such, the disciplinary coerciveness of the institutions of industrial capitalism, exposed in post-68

21. For avant-garde and biopolitics, see my article: A. Penzin, 'The Bio-politics of the Soviet Avant-Garde' in *Pedagogical Poem. The Archive of the Future Museum of History*, Marsilio Editori, 2014. I analyze there several types of biopolitical strategies in the theories and practices of the 1920s.

radical thought, as in Michel Foucault's analysis of power and the critique of the traditional workers movement in the Italian Autonomist Marxism, have made it almost impossible to dream of a harmonious fusion of art and the factory. Industrial production no longer appears to possess the 'inspiring' forms and transformative horizons that Arvatov took for granted. Moreover, under new post-Fordist conditions of production some of the art/industry 'fusions' aspired to by Arvatov and his fellow-thinkers, have perversely, been achieved today on the shop floor and in the office – not through a socialist organization of the everyday but as a result of a new process of capitalist valorization that captures previously marginal human qualities and activities associated with non-productive aspects of 'life' – for example, the rise of the 'virtuoso' service worker whose work is public, performance-based, and in certain respects similar to the processual activity of artistic work, etc.[22] But the general programme of militant inquiry into art and industry proposed by Arvatov, which insists on finding ways out of the enclosure of artistic and cultural practices inside the institutional borders of bourgeois life, into an 'outside world' of the organization of life and social production, remains to be achieved, and therefore, is still vital to any critically-minded artist, activist or theorist. Any new revolutionary or eventual rupture within the all-encompassing

22. Philosophically, these new 'fusions' were articulated in such works in the previous decade as: *A Grammar of the Multitude. For an Analysis of Contemporary Forms of Life* by Paolo Virno, who ironically called this new condition a perverted 'communism of capital' (Semiotexte, New York, 2004). Compare it with Arvatov's remarks on the artist as a model worker: 'The proletarian artist must be the equal builder of everyday life and not a priest of art. It is necessary for him to be a model for every worker, so that the products of his labour and the methods of his activity are adopted everywhere.'

texture of current capitalist domination, will bring about again – with an increased intensity and acceleration – the set of the possibilities on which Arvatov based his outstanding and visionary theoretical work. The rethinking of his proposals thus remains an essential task for any radical and ambitious programme of artistic and political intervention into revolutionizing society.[23]

23. I would like to express my gratitude to Maria Chekhonadskih (CRMEP at Kingston University) whose doctoral research is focused on early Soviet theory and philosophy and whose consultations were invaluable in writing this text.

Index

concept of 17n2
depiction of 117
disorganization of 108–10, 113,
118–19, 121
fusion of art with 111–13
removal of art from 26–9, 34–5,
58–9, 110
'Everyday Life and the Culture of
the Thing' 130–1
exports, art as 23
Expressionism/Expressionists 61–2,
63, 71, 86

factories
applied art 36, 37–8, 78–9, 88,
94, 114
exclusion of artists from 29–30,
33–4
potential role of artists in 3–6,
138
Prokatchik metal factory 10–12
see also production
fetishization 7, 12, 96–7
film 3, 95, 104, 114, 118
folk art 20–1
form
in bourgeois society 26–9, 31–3,
37
in Constructivism 72
easel art and 66
everyday life and 108–11
in machine production 37–8
Formalism 61
France and French art 2n1, 44n14,
45, 115, 116
French, John 42n13
French Revolution 34, 45, 66
frescoes 57, 67–9
Futurists/Futurism 23, 80, 83–4

Gauguin, Paul 62n12, 68

general social technique 8–9, 12,
32, 94–5
Géricault, Théodore 66
Germany/German art 2n1, 55, 67,
69, 78–9, 128n10
Giotto 57, 70
Gothic style 43, 44
Gough, Maria 1–2, 2n1, 10, 10n2,
127n8, 128n10
graphic art 69
Great French Revolution 34, 45
Great War 42
Greek style and art 46, 70, 90, 115
Greenberg, Clement 130
Groys, Boris 127n6
guild society 16–19, 23–4, 25, 50–1,
131–2

Hildebrandt, Theodor 55
Houticq, Louis (quotation by)
43–4
human beings, depiction of 116–17

ideology 101–8
Impressionism/Impressionists 23,
37, 55, 61, 61n11, 69, 102,
115
individualism 51–3, 60, 66, 97
industrial capitalism 33–8, 115,
137–8 *see also* production
information kiosks 4
INKhUK (Institute of Artistic
Culture) 10–11, 86, 125
instruments 97
intelligentsia 21, 22, 38–43, 71,
75–9, 98
Ioganson, Karl 10–12
iskusstvo/iskusny 24n8
Italian Autonomist Marxism 138
Italy and Italian art 24, 43–4, 57,
114, 115, 138
Itinerants 117